BASEBALL
IN ST. LOUIS
1900–1925

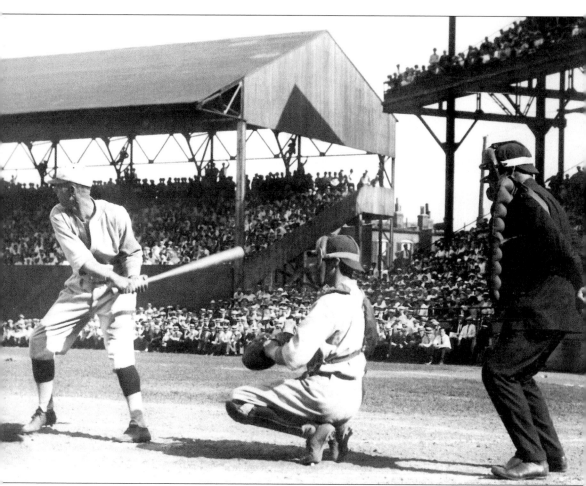

KEN WILLIAMS AT SPORTSMAN'S PARK. A tall and slender figure at the plate, Ken Williams of the St. Louis Browns led the American League in home runs in 1922. He coiled and cocked his bat back waiting for the pitch, as seen here in this image. 1922 was the high point for St. Louis baseball in this quarter century. The crowds at Sportsman's Park were large, and Williams was a symbol of the Browns' hitting success. He was also very popular with teammates and fans alike. (Courtesy of *The Sporting News*.)

Front Cover photos: George Sisler of the Browns (Courtesy of the Chicago Historical Society); Rogers Hornsby of the Cardinals (Courtesy of the National Baseball Hall of Fame Library, Cooperstown, NY.)
Back Cover photo: Branch Rickey as manager of the Cardinals, c.1924 (Courtesy of the Private Collection of Dennis Goldstein.)

BASEBALL
IN ST. LOUIS
1900–1925

Steve Steinberg

ARCADIA

Published by Arcadia Publishing,
Charleston SC, Chicago IL, Portsmouth NH, San Francisco CA

Printed in Great Britain.

Library of Congress Catalog Card Number: 2004106225

For all general information contact Arcadia Publishing at:
Telephone 843-853-2070
Fax 843-853-0044
E-Mail sales@arcadiapublishing.com

For customer service and orders:
Toll-Free 1-888-313-2665

Visit us on the internet at http://www.arcadiapublishing.com

*For Gene Karst (1906–2004), a dear friend who took me back in time.
Born in 1906 and still sharing memories in 2004.*

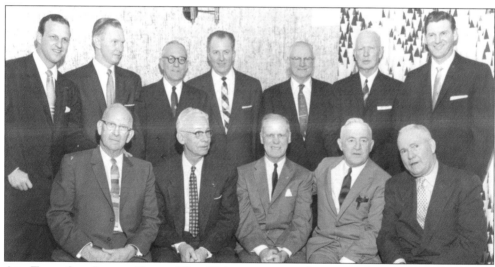

ALL-TIME ST. LOUIS TEAM. The 50th anniversary banquet of the Baseball Writers' Association of America (BBWAA) was held in St. Louis on January 20, 1958, at the Sheraton-Jefferson Hotel. Bob Broeg, sports editor of the *Post-Dispatch* and BBWAA president at the time, coordinated the selection of the all-time St. Louis team, with input from his colleagues. The team, most of whose members appear in this photo, from left to right, consisted of (front row) Jesse Haines (pitcher), Ken Williams (left field), George Sisler (first base), Frank Frisch (third base), and Rogers Hornsby (second base); (back row) Stan Musial (right field), Red Schoendienst (utility infielder), John Tobin (utility outfielder), Terry Moore (center fielder), Bob O'Farrell (catcher), Hank Severeid (catcher), and Marty Marion (shortstop). Not pictured are Dizzy Dean (pitcher), Grover Cleveland Alexander (pitcher; deceased), and Urban Shocker (pitcher; deceased). The group is almost evenly split between the first quarter and the second quarter of the 20th century. (Courtesy of the *St. Louis Post-Dispatch*.)

CONTENTS

ACKNOWLEDGMENTS

I want to thank my colleagues in SABR, the Society for American Baseball Research, especially those of the Deadball Committee, whose time period (1901–1919) overlaps with that of this book. They provide an enormous database of knowledge and are always ready to contribute with their expertise. St. Louis writers and historians Gene Karst and Bob Broeg, as well as Cooperstown's Cliff Kachline, were an invaluable joy, with their recollections of the people and stories in this book. Bill Deane, fact-checker extraordinaire, zeroes in on a manuscript and finds errors that can be easily overlooked. My fellow time-traveler (to baseball's past) Eric Sallee gave me the insight to take a comprehensive approach to this book and provided input for this "kid in a candy store," who had so many goodies to choose from. This work is a combination of information and images, and the bio files of the National Baseball Hall of Fame Library in Cooperstown, New York, and *The Sporting News* in St. Louis, Missouri, provided much information that fleshed out the people in this book. Ron Selter provided details on Sportsman's Park and Larry Lester helped with Negro League ball. Jeff Ruetsche, my Arcadia editor, was always there with ideas and flexibility, and gave me the creative license to write this book as I envisioned it. I also want to thank John Thorn, Stephanie Nordmann for her St. Louis research help, and Jennifer McCord for her invaluable ideas and advice.

Ultimately it is the images that make the words come alive, and many of these photographs have rarely been published or appear in print for the first time. I want to thank: Bill Burdick and the National Baseball Hall of Fame Library in Cooperstown, Charles Brown and the St. Louis Mercantile Library at the University of Missouri-St. Louis, Piriya Metcalfe and the Chicago Historical Society, Paula Homan and the St. Louis Cardinals Hall of Fame Museum, Ellen Thomasson and the Missouri Historical Society, Steve Gietschier and *The Sporting News*, Mary Ison and the Library of Congress, Prints and Photographs Division, and private collectors Dennis Goldstein, Michael Mumby, and Jay Sanford. I also really appreciate the help and images provided by Allen Reuben and Culver Pictures, Mark Rucker and Transcendental Graphics, Mary Brace and Brace Photo, Ann Salsich and the Western Reserve Historical Society in Cleveland, and Tom Shieber and the SABR-Ottoson Collection. There are also some wonderful collections at public libraries; thanks to Dawn Eurich and the Burton Historical Collection at the Detroit Public Library (thank you, Ernie Harwell, for the wonderful collection you donated to that library), Melinda Schafer and the Cleveland Public Library Photograph Collection, Tom Featherstone and the Walter P. Reuther Library at Wayne State University, Aaron Schmidt and the Boston Public Library, and Jean Gosebrink and the St. Louis Public Library Special Collections. Thanks also to Margaret Jerrido at the Samuel Paley Library at Temple University, Hillary Levin at the *St. Louis Post-Dispatch*, and Lisa Nelson at AP/Wide World Photos. This book was rounded out with wonderful images from Paul Sallee, Dave Eskenazi, Charles Donovan, the son of Patsy Donovan (Patsy was born in 1865), and the granddaughter of Bob Quinn (who happens to be married to one of the best executives in baseball), Margo Quinn Hemond.

INTRODUCTION

St. Louis is still the greatest ball town in the world.
Any town will support a winner, but it takes a real
baseball burg to support two losers.

–Robert Hedges, owner, St. Louis Browns, 1902–1915

Baseball in St. Louis, 1900–1925: A time period of significance, with colorful and important baseball personalities, including some of the greatest players in the history of the game. Nineteen twenty-six was the beginning of a glorious era in St. Louis baseball, the year the St. Louis Cardinals won their first National League pennant and World Series. They would go on to capture nine pennants and six world championships in 21 years. During that time, except for the wartime pennant of 1944, the St. Louis Browns were baseball's hapless losers, St. Louis' second team. In the distant past, the late 1880s, St. Louis had four pennant winners, the 1885–1888 Browns of the American Association.

Baseball in St. Louis in the first quarter of the 20th century? Overlooked and almost forgotten. No pennant winners. Few winning teams and even fewer really good ones. St. Louis teams of this era reflected baseball's "have-nots": weak teams with limited financial resources, hard-pressed to compete with the powerful teams in New York and Chicago (National League), in Philadelphia and Boston (American League).

Baseball in St. Louis, 1900–1925. Some of the game's zaniest and most colorful characters. Tragedy did not pass over St. Louis, and neither did controversy. Promising athletes were struck down in the prime of their lives. Others were banned from organized ball forever, because of charges they compromised the game. The firestorm of gambling scandals that swept over baseball in the late 'teens and 1920s did not spare St. Louis.

Baseball in St. Louis, 1900–1925. The battleground of two of the game's greatest wars: the rise of the American League in 1901–1902 and the Federal League conflict of 1914–1915. Baseball in St. Louis: the National League, the American League, the Federal League, the Negro Leagues, and even semi-pro ball, led by the Trolley League. This was the time when St. Louis was more Brown than Red, more AL than NL.

It was also black. Black players of this era had the misfortune—all of baseball had the misfortune—of not being able to compete with major leaguers, except in occasional exhibition games. Until 1920, black clubs were not organized into formal leagues with set schedules; they often barnstormed. Even when the structure came in 1920, in the form of the Negro National League, few records were kept, and even fewer images were preserved. There remain far fewer images of black baseball from this period in St. Louis than in other cities, such as Chicago, Detroit, Kansas City, and Pittsburgh.

Baseball in St. Louis, 1900–1925. Two of the greatest hitters in history, playing in the same city on alternating days. One of the most creative and important executives the game has known. Twenty-one men who are enshrined in Cooperstown's Baseball Hall of Fame wore a St. Louis uniform at some time between 1900 and 1925.

Baseball in St. Louis, 1900–1925. The western outpost of major league ball. A breeding ground for many major leaguers far out of proportion to the population. Teams here carried the aspirations of fans in a large geographic area. St. Louis baseball reflected the challenges and resourcefulness of the small market, driven by necessity, yet driven to win.

BIBLIOGRAPHY

Early on, I decided to take a comprehensive approach to this book. While this work is by no means definitive, my goal has been to give the reader a good understanding of baseball in St. Louis during this quarter century. I have devoted special attention to significant and fascinating people who have often been overlooked. Therefore I have longer essays not simply for the three men on this cover (George Sisler and Rogers Hornsby on the front and Branch Rickey on the back), but also for people like owner Bob Hedges, business manager Bob Quinn, pitchers Urban Shocker and Dave Danforth, and position players Ed Konetchy, Jack Miller, and Del Pratt.

I am commenting here on St. Louis baseball books that include the early 20th century. I have also drawn on many general baseball books, including *Total Baseball* (Total Sports, 7th edition, 2001) for statistics. There are more books on the Cardinals, who continue to thrive as a franchise, than on the Browns, who played their last ballgame more than 50 years ago. There are two Cardinal reference books, Mike Eisenbath's *The Cardinals Encyclopedia* (Philadelphia: Temple University Press, 1999) and *The St. Louis Cardinals Encyclopedia* by Bob Broeg and Jerry Vickery (New York: McGraw-Hill, 1998). Bob Broeg's *Memories of a Hall Fame Sportswriter* (Champaign, IL: Sagamore, 1995) looks back at the people and events in his long career. Among his other books is *Bob Broeg's Redbirds: A Century of Cardinals' Baseball* (St. Louis: River City Publishing, 1987).

Fred Lieb's classic, *The St. Louis Cardinals: The Story of a Great Ballclub,* has been reissued by Southern Illinois Press (Carbondale, 2001) and covers this time period very well. Rob Rains offers *The St. Louis Cardinals: The 100th Anniversary History* (New York: St. Martin's Press, 1993). Donald Honig's *The St. Louis Cardinals: An Illustrated History* (New York: Simon and Schuster, 1991) and Mark Stang's *Cardinals Collection: 100 Years of St. Louis Cardinal Images* (Wilmington, OH: Orange Frazer Press, 2002) both have photos and text. Bob Tiemann's *Cardinal Classics: Outstanding Games from Each of the St. Louis Ballclub's 100 Seasons* (St. Louis: Baseball Histories, 1982) focuses in-depth on one game each year. And for the glory years of the championship Cardinals of the American Association back in the 1880s, there is Jon David Cash's *Before They were Cardinals: Major League Baseball in Nineteenth-Century St. Louis* (Columbia: University of Missouri Press, 2002).

Biographies of two key figures in St. Louis baseball are also useful. They include some books on or by Rogers Hornsby: Charles Alexander's *Rogers Hornsby* (New York: Henry Holt, 1995), Hornsby's own *My War with Baseball* (New York: Coward-McCann, 1962), and Hornsby's *My Kind of Baseball* (New York: David McKay, 1953). Two Branch Rickey bios are Arthur Mann's *Branch Rickey: American in Action* (Boston: Houghton Mifflin: 1957) and Murray Polner's *Branch Rickey: A Biography* (New York: Simon and Schuster, 1982).

For the Browns, Peter Golenbock has an Oral History of Baseball in St. Louis, and it covers the Browns as well as the Cardinals. *The Spirit of St. Louis: A History of the St. Louis Cardinals and Browns* (New York: Morrow/Avon, 2000) quotes from people who were there as baseball history was being made. Roger Launius looks at baseball in St. Louis and Kansas City in *Seasons in the Sun: The Story of Big League Baseball in Missouri* (Columbia: University of Missouri Press, 2002). Roger Godin has written a detailed account of the famous Browns' pennant race, called *The 1922 St. Louis Cardinals: Best of the AL's Worst* (Jefferson, NC: McFarland, 1991). Bill Borst, founder of the Browns Fan Club, has published a number of small yet informative books on the Browns, including: *The St. Louis Browns through the Years* (Borst, 1987), *Still Last in the American League: The St. Louis Browns Revisited* (W. Bloomfield, MI: A&M, 1992), *Baseball through a Knothole* (St. Louis: Krank Press, 1980), and a three-volume set with a brief profile on every Brown, called *Ables to Zoldak* (St. Louis: St. Louis Browns Press, 1988). There is also an active St. Louis Browns Historical Society, which publishes an informative newsletter.

ONE

The Early Years

1900–1908

The year 1901 is the start of the Modern Era in baseball. It was the first year of the American League and the year that foul balls, except after two strikes, began to count as strikes (in the National League; the AL would adopt this rule in 1903).

In the short space of four years, the St. Louis Cardinals rode a roller coaster of highs and lows. In 1899 Frank and Stanley Robison, owners of the Cleveland Spiders of the National League, acquired the St. Louis National League team and decided to focus their resources on St. Louis, at the expense of Cleveland. They moved their best players from the Spiders to the Cards. After winning less than 30 percent of their games the previous four years, St. Louis' N.L. team rose to 84-67 in 1899. And the decimated Cleveland team set an all-time mark of baseball futility, with a record of 20-134.

The tables were soon turned on the Cardinals. When the American League was formed in 1901, it lured away some of the team's top players of 1900, including future Hall-of-Famers Cy Young, John McGraw, and Wilbert Robinson, as well as hitting star Mike Donlin. A year later, the upstart league relocated its Milwaukee franchise, which Robert Hedges bought for $35,000, to St. Louis. The new team took the name of the great Browns of the 1880s, played in their old ballpark, and stocked the squad with the remaining stars of the 1901 Cardinals.

Jimmy McAleer was the new Browns' manager and also the confidant of American League president Ban Johnson. With an ample budget in hand, McAleer did the recruiting (NL partisans called it "raiding") from the Cardinals, and the Browns then withstood a flurry of legal challenges to field this stellar cast. Ironically, McAleer had played for the Robisons' Cleveland teams of the 1890s.

Never before, and perhaps never since, did one team so deplete another team. The Cardinals' three best pitchers, two top infielders, and two outfield stars all joined the city's new franchise. The Cardinals suffered the very fate they brought on the Cleveland Spiders just three years earlier. They would not recover for years.

In their inaugural 1902 season, the Browns brought a pennant race to St. Louis, while Cardinal manager Patsy Donovan could only wonder what might have been. The Browns were in first place in mid-August and just one-half game behind on September 5. They finished in second place, just five games behind Connie Mack's Philadelphia Athletics.

The intra-city transfer of talent, and results, were incredible. Pitcher Jack Powell, who'd won 19 games for the '01 Cardinals, won 22 games for the '02 Browns. The loss of pitchers Jack Harper and Willie Sudhoff, 23 wins and 17 wins, respectively, in 1901, further devestated the Cardinals staff; in '02, the two had a combined 27 wins for the Browns. At the plate, the Cardinals loss was yet another a gain for the Browns: shotstop Bobby Wallace (.324 in '01/.285 in '02), second baseman Dick Padden (.256/.264), and outfielders Jesse Burkett (.376/.306) and Emmet Heidrick (.339/.289) were each major transfers of talent between the St. Louis ballclubs.

When the two leagues settled after the 1902 season, the National Agreement allowed American League teams to keep the players they had pulled from the established league in the previous two years.

The Cardinals finished 44 1/2 games behind the pennant-winning Pittsburgh Pirates in 1902. In the next eight years, they finished an average of almost 50 games out of first place. During that time, the Robisons went through six managers (including owner Stanley himself) and never finished higher than fifth place.

The Browns did not come close to their '02 performance until 1908. A key trade and the acquisition of a couple of veteran pitchers gave the club a boost. Jimmy McAleer was still at the helm, and Jack Powell (after a couple of seasons in New York) teamed with the mercurial Rube Waddell to anchor a pitching staff that made another run for the flag. The 1908 pennant races in both leagues were two of the greatest in history. The Browns were only a half-game out of first place on September 5, before fading to fourth place, 6 1/2 games behind the pennant-winning Detroit Tigers.

The 1908 Browns outdrew the Cardinals for the sixth time in their seven-year existence. Their attendance of more than 618,000 fans was a large number for those times and triple that of the Cards. Among St. Louis teams, only the '22 Browns would draw more fans in the first quarter of the century.

As 1908 drew to a close, Bob Hedges took a big part of the money he had made that season and plowed it back into Sportsman's Park, home of the Browns. The major expansion and remodeling increased the capacity and gave St. Louis one of the nation's first steel and concrete grandstands.

At the same time, just a few blocks away, Stanley Robison created a buzz of excitement by signing one of the game's best players and most dynamic personalities as his team's new player-manager, Roger Bresnahan.

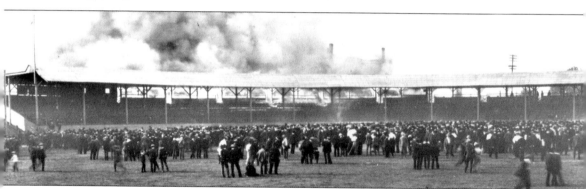

1901 FIRE AT LEAGUE PARK. On May 4, 1901, a fire broke out at the Cardinals' park, then known as League Park. It started under the grandstands, probably by an errant cigarette, and the winds quickly fanned the flames. Most of the 7,000 fans escaped injury by jumping onto the playing field. *The Republic's* account reminds us just how quickly these ballpark fires spread:

> *In twenty minutes the grandstand, pavilions and offices… were totally destroyed… The wooden stands burned like tinder and a strong wind from the southeast fanned the flames. When the fire was hottest the flames leaped in tongued shapes fifty and one hundred feet in [the] air.*

While the damage was extensive, the park was quickly repaired, though it wasn't modernized. Unlike Sportsman's Park, where the Browns played since they began in 1902, the Cardinals' home had few improvements over the years. By the time the Cards moved into Sportsman's Park in 1920, Cardinal Field (as it was then called) was extremely run down. It was one of the last old wooden ballparks in the major leagues. (Courtesy of Charles Foster Bartlett/Missouri Historical Society, St. Louis.)

FRANK ROBISON (*left*) AND M. STANLEY ROBISON (*right*). The Robison brothers made their fortune in the streetcar business in the Midwest. They operated street railway lines in Fort Wayne, Indiana and Cleveland, Ohio. Frank married the daughter of his partner Charles Hathaway, and Stanley was a bachelor devoted to his nieces. In the 1890s, the brothers owned the Cleveland Spiders, which won the Temple Cup (post-season championship between the National League's top two teams) in 1895 and lost it in 1896.

When the Robisons bought the St. Louis National League team in early 1899, they proceeded to move their best Cleveland players to St. Louis. The Missouri team, which had lost 111 games in 1898, went 84-67 in 1899. In the meantime, the depleted Spiders set an all-time record for futility: 20 wins and 134 losses, for a .130 winning percentage. In 1900, the Robisons went a step further: they signed Brooklyn stars Wilbert Robinson and John McGraw to supplement their strong core, but the team finished disappointingly, below .500.

Frank was the more dominant of the two brothers. He had been the Spiders' president for a decade and assumed the presidency of the St. Louis team (which was actually called the Browns at first and now had become the Cardinals). He gave up that role and left baseball in 1906, though he still retained his stock. When he died less than two years later, it was widely assumed that the team would be sold. After all, he had no sons (one of his daughters, Helene, had been a Spider mascot as a child), and his brother Stanley was not as strong a personality as Frank was. Stanley was a mild and unassuming man, who had tried his own hand at managing the Cards during the 1905 season. He not only kept the team; he made a major move in hiring Roger Bresnahan. He worked out the details of the "trade" with Bresnahan's New York manager and Robison's former (1900) player, John McGraw. In the spring of 1911, Stanley died, and his niece Helene Hathaway Britton inherited the team. (Frank Robison, Courtesy of *The Sporting News*.)

ROBERT HEDGES.

The biggest menace in baseball is the presence of so much
money behind certain clubs. There are in both big leagues men
who can buy winners. If they allow that ability to run to extremes,
the game will suffer greatly. The weak fellows have no chance
against men who can bid up to the skies for players.
—Robert Hedges, *New York Press*, March 1, 1916

A progressive, almost revolutionary figure in baseball history, Bob Hedges (pictured above) has been virtually forgotten for decades…because his revolution did not succeed. Yet his ideas raised critical issues and planted seeds in the minds of others. He brought Branch Rickey back into baseball in 1913 and was the young man's first mentor as an executive. Rickey took many of Hedges' ideas and made them a reality when he moved to the Cardinals.

Bob Hedges was a daring and striking self-made man, a carriage manufacturer from Cincinnati. His father died when he was young, and his brothers were killed in a Kansas City tornado in the 1880s. He bought the American League's Milwaukee Brewers for around $35,000 and moved the team to St. Louis. He then instituted a number of innovative policies to make the ballpark less hospitable for "Rowdies": hiring security guards to quell violence and convey a sense of safety at the ballpark; kicking the saloon out of baseball by banning the sale of alcohol at the games; encouraging and fostering Ladies' Day. He also jump-started his team by hiring virtually every star from the established St. Louis Cardinals. The ensuing legal wrangles, in which he ultimately prevailed, literally split St. Louis. Ultimately, the courts ruled in his favor because of the "lack of mutuality" in personnel matters. It was only fair that the players could have options in choosing where they work, the courts said.

Hedges also built the first steel and concrete ballpark. With the history of fires burning down wooden stadiums, especially in St. Louis, this was a significant move. While Philadelphia's Shibe Park usually gets credit as the first modern facility, Hedges has at least a partial claim. In 1908 he made over $160,000 profit from the pennant race season. He then totally remodeled, reconfigured, and expanded Sportsman's Park by relocating home plate, with all new double-decked steel and concrete grandstands. Since the old grandstands now became part of the outfield seating, it was technically not an all-new stadium.

Hedges identified the challenge of competing with wealthier clubs and a response to it. His solution was the "farming out" of young players, with formal agreements with, and even control of, minor league teams. In 1913 he lent four Alabama businessmen the money to buy the Montgomery club. This was the team from which his sensational rookie Del Pratt had come the year before. But the four partners had a falling out, and the plan fell through. As with the new stadium, Hedges may not have had exclusive ownership of the concept, but he certainly studied the matter and set plans in motion. He even hired a man to run his farm system: Branch Rickey.

Hedges gamely fought battles for his franchise's personnel, fighting back against the Federal League (the Earl Hamilton case) and signing George Sisler, despite the controversy it engendered. The Federal League war created enormous economic hardships, and Hedges had to put his farm plan on hold. In early 1916, after the Feds had folded, Bob Hedges folded his hand too. He sold the Browns to Federal League magnate Phil Ball, as part of the settlement with organized baseball. At first, there were reports that Ball would buy the Cardinals from Helene Britton, who was making it known that her team was now for sale, for the right price.

Why did Hedges sell out? He had grown weary of his inability to build a championship team. The promise of 1902 and 1908 was followed by the demoralizing fall-off of 1903 ($14^1/_2$ games worse than '02) and 1909 (21 games worse than '08). Also, after the continuity at the helm for eight years with Jimmy McAleer, he had gone through a revolving door of mistaken appointments for skipper: O'Connor, Wallace, and Stovall. Hedges had addressed the issue to some extent with the Rickey appointment, but that move didn't bring much improvement in the standings. Hedges was also worried about the impact of two wars: the World War, which showed no signs of receding, and the Federal League antitrust lawsuit pursued by the Baltimore Feds, who were not a party to the settlement. Finally, the National Agreement of 1913 banned the ownership of minor league teams by major league franchises, as of January 1, 1914, and he had a one-time window to cash out and multiply his initial investment more than ten-fold.

Hedges sold his team for around $425,000. Before he did so, he saw to it that Rickey had a contract for the 1916 season. Also, Hedges was a caring and generous owner, lending and advancing money to his players. All these entries on the Browns' books complicated the sale to Ball and even threatened it for a while. When he sold the team, Hedges returned to the issue of his greatest concern for the health of baseball, in the quote at the beginning of this profile. His son married Sam Breadon's daughter and worked for St. Louis philanthropist and baseball booster, Mark Steinberg. (Courtesy of the Library of Congress, Prints and Photographs Division.)

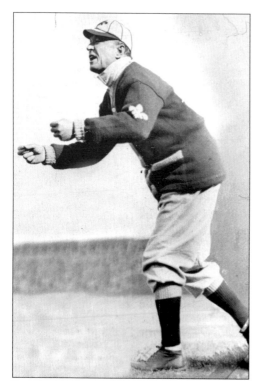

JIMMY MCALEER. "How he could catch outfield flies! You could write a ream about his great plays" read an editorial in *The Sporting News*, May 7, 1931. One of the primary forces behind the rise of the American League, McAleer came out of retirement to help league founder Ban Johnson recruit players for the St. Louis Browns. He succeeded in luring virtually every top St. Louis Cardinal player to the new league. McAleer *(left)* was a spectacular outfielder for the Cleveland Spiders in the 1890s. Long before Tris Speaker, he played shallow to cut down on hits and ran back to catch fly balls. Like Patsy Donovan, he managed in the bigs for 11 years. Ironically, when Donovan was replaced as manager of the Boston Red Sox after the 1911 season, McAleer *(right)* was part of the team's new ownership. He later had a falling out with his old colleague Ban Johnson and with Red Sox manager Jake Stahl, which led to the sale of the team to Joe Lannin in 1914. McAleer was equally comfortable exhorting his troops in uniform as he was reviewing the day's strategy in a suit. (Image on left courtesy of the Western Reserve Historical Society, Cleveland, Ohio; image on right courtesy of the the Private Collection of Dennis Goldstein.)

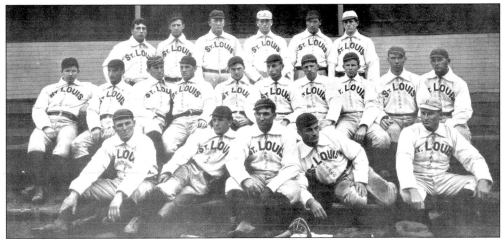

1900 ST. LOUIS CARDINALS. The year before the start of the modern era and rise of the American League, the Cardinals added a couple of future Hall-of-Famers to their roster. John McGraw and Wilbert Robinson joined the team in mid-season and are not in this photo, which was part of a "broadside" that was posted at the ballpark and contained the team's schedule and advertisers. The mighty pitcher, Cy Young, is in the top row (third from left) next to Patsy Donovan (fourth from left). In the middle row are four Cardinals who jumped to the 1902 Browns (starting on far left), Jack Powell, Bobby Wallace, Emmet Heidrick, and Jesse Burkett. Just to the right of Burkett is Mike Donlin, who went on to star for the Cincinnati Reds and New York Giants. The team's manager, Patsy Tebeau, is to the right of Donlin (middle row, sixth from left). "Rowdy Jack" O'Connor is in the bottom row (far left). The 1900 Cardinals were disappointing on the playing field: after winning 84 games in 1899, the year all the talent came from Cleveland, the 1900 club won only 65 games. Young, Donlin, McGraw, and Robinson all jumped to the new American League the following year. (Courtesy of the Private Collection of Dennis Goldstein.)

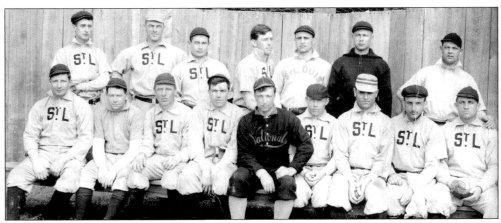

1903 ST. LOUIS BROWNS. After the promising second-place finish in their inaugural season of 1902, the Browns assembled in Baton Rouge, Louisiana for 1903 spring training. Manager Jimmy McAleer is wearing the "Nationals" jacket in the middle of the front row. Burly Jack Powell is at the far left of that row, Joe Sugden is third from the left, and Jesse Burkett is at the far right, with Bobby Wallace next to him. John Anderson (second from the left in the top row) was born in Norway and hit .284 in both 1902 and 1903. (Courtesy of the Private Collection of Dennis Goldstein.)

PATRICK "PATSY" DONOVAN. "Donovan never has been rated as highly as his abilities deserved. He was fast, smart, a magnificent thrower and fielder, but so quiet and gentlemanly, he was never sensational." So opined Hugh Fullerton, in *The Sporting News*, January 9, 1936, in selecting Donovan for his all-time Cardinal team. Donovan was the player-manager of the Cardinals from 1901 to 1903, after a successful career as a speedy outfielder in the 1890s. He was replaced as manager of the Pittsburgh Pirates, the team he had starred for, when new owner Barney Dreyfuss bought the team in early 1900. The Pirates then won the pennant three straight years, 1901–1903. Donovan's 1901 Cardinals lost most of their best players to the new American League's St. Louis Browns. He was replaced as manager of the Boston Red Sox after the 1911 season, and they went on to win the World Series the following year and four times in the next seven years. Donovan was the man who molded the great Boston outfield of Speaker, Hooper, and Lewis. (Courtesy of the Boston Public Library, Print Department, and the Donovan Family.)

DONOVAN'S SUCCESS AND STYLE.
Born in Ireland, Donovan had a career .301 batting average, with 518 stolen bases in a 17-year playing career. In 1914, while scouting for the Red Sox, he recommended that they buy a young pitcher from Baltimore by the name of Babe Ruth. Donovan's Buffalo Bisons won the 1915 and 1916 International League pennants with a group of players who would go on to succeed in the bigs, including pitcher Herb Pennock and infielders Joe Judge and Joe McCarthy. Donovan capped a career of more than 60 years in organized ball as a scout for the New York Yankees. Whether playing, managing, or scouting, he had the reputation as a decent and stylish gentleman, in an era when there weren't many of his kind on the playing field. (Courtesy of the Library of Congress, Prints and Photographs Division.)

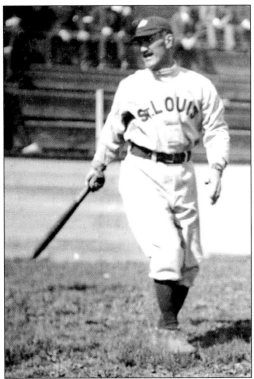

JAKE "EAGLE EYE" BECKLEY. One of the 19th century's greatest first basemen, he played for the Cardinals at the end of his long career, from 1904 to 1907. A career .308 batter with 2,934 hits, his 2,380 games at first base stood as a record until Eddie Murray broke it in 1994. His 23,731 putouts at first base is still the record, with his Cardinal successor at first base, Ed Konetchy, second. His 244 triples (fourth all-time) are a reflection of a power hitter in his day. He also hit three home runs in a game in 1897. A gentleman in an age of rowdyism, by the time he played for St. Louis, when facial hair was becoming a mark of the past, Beckley stood out with his distinctive moustache. He was elected to the Baseball Hall of Fame in 1971. (Courtesy of the Chicago Historical Society.)

JESSE BURKETT. As a member of the Cardinals, he led the National League in hitting in 1901. By the time Burkett jumped to the Browns the following year, his skills were starting to erode. The only man besides Cobb and Hornsby to post back-to-back .400 seasons (1895–1896), his career batting average was .338. His specialties were bunting, and fouling off pitches, which he could do almost indefinitely. He was said to be the inspiration of the rule that a bunt foul with two strikes was an out. Burkett was nicknamed "The Crab" for his acerbic personality. He gave back the taunts that the crowd in the left field bleachers threw his way because of his weak fielding, especially when he started to slow down late in his career. He later had a long stint as an owner and player-manager, for Worcester of the New England League. He also coached baseball at Holy Cross and Assumption Colleges. (Courtesy of the Chicago Historical Society.)

COACH BURKETT. In 1921, John McGraw of the Giants hired Burkett as a coach. The following year, he was the "keeper" of talented but erratic New York pitcher Phil Douglas, one of the heroes of the 1921 World Series. Burkett, who drank little and didn't smoke, was to keep the alcoholic pitcher out of harm's way—away from bars, taverns, and liquor. Douglas eventually evaded his baseball bodyguard, disappeared, and was found in a drunken stupor. He also wrote an incriminating letter to a former teammate, Les Mann of the Cardinals, that soon ended Douglas' career. In it, the pitcher asked for "an inducement" to quit the Giants. "The Crab" mellowed somewhat in his later life and appeared on the banquet circuit. He was elected to the Baseball Hall of Fame in 1946.

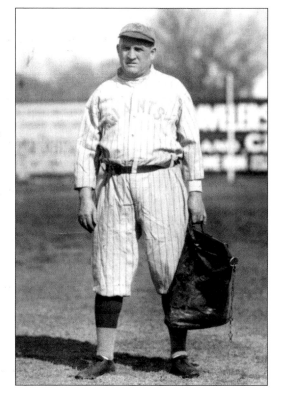

MORDECAI "MINER" BROWN. The pitching staff mainstay of the great Chicago Cub teams of 1906–1911, Brown started his big league career in St. Louis. In his rookie 1903 season, he appeared in 26 games, going 9-13 for the Cardinals. At the end of the year, they dealt him to the Cubs for pitcher Jack Taylor and shortstop Larry McLean. After losing most of their best players to the Browns a year earlier, the Cardinals wanted an established star. That they got in Taylor who had just posted back-to-back 20-win seasons. Brown blossomed with the Cubs. After warming up in 1904–1905 (with a record of 33-22), he reeled off six straight 20-win seasons, going 148–55, with an earned run average of less than 2.00 in five of them. The Cubs won pennants in four of those seasons and finished in second place in the other two. (Courtesy of Brace Photo.)

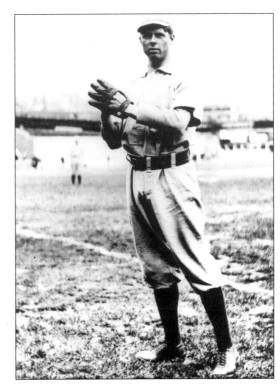

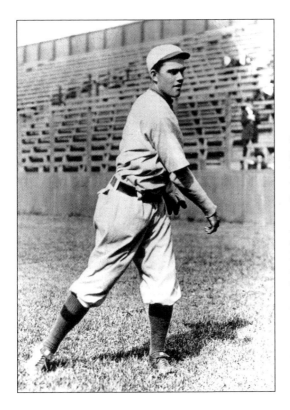

CHARLES "BABE" ADAMS. One of the great control pitchers of all time, he won three games for the Pittsburgh Pirates in the 1909 World Series, in his rookie season. Adams first pitched in the majors in 1906, for the St. Louis Cardinals. After he appeared in just one game that spring, they let him go. In 1916, Adams had fallen back to the minors with a sore arm after winning more than 100 games for the Pirates. Former Cardinal scout Bob Connery, who had gone to the New York Yankees with manager Miller Huggins, recommended that the Yankees sign Adams. They did not, and the pitcher returned to Pittsburgh, where he won another 81 games. (Courtesy of Brace Photo.)

19

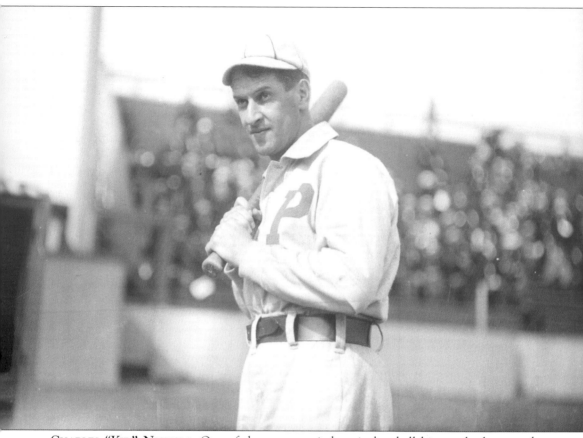

CHARLES "KID" NICHOLS. One of the greatest pitchers in baseball history, he became the Cardinals' player-manager in 1904, the twilight of his hurling career. He won 21 games that year—his 11th 20-win season in his 13 years in the bigs. The team improved dramatically in 1904, going from 43 wins (and last place) to 75 wins (and fifth place). Early in the next season, he departed in a dispute with owner Stanley Robison over a task Nichols felt he shouldn't do. Visiting team managers often kept an eye on ticket sales and the entrances of stadiums, to make sure they were getting the fair visitors' team share of box-office receipts. Since he was both a pitcher and a manager, Nichols felt that someone else could do the job. It is not clear whether former player-manager Patsy Donovan handled the task without complaining or how Nichols handled it the previous year. He stayed on with the team for a while longer and was then released to the Phils. Seen here shortly after the move, Nichols felt he still could contribute from the mound. He went 10-6 for the rest of the season, with one of the lowest earned run averages of his career.

As a pitcher, Nichols' numbers are staggering: seven seasons of 30 or more wins and 300 victories by the age of 30 (both are records). He did not use a wind-up, which he felt hurt his control. When he started in the minors as a 17-year-old at Kansas City, he was so small that he was tagged "Kid." The nickname stuck, even though he filled out from about 135 to 175 pounds and over 5 feet, 10 inches. While the rules were different in the 1890s, that era had a championship series, played by the winners of each half of a split-season. Nichols was the star of the 1892 series with two wins, as Boston beat Cy Young and the Cleveland Spiders' team, which was owned by the Robison brothers. (Courtesy of the Chicago Historical Society.)

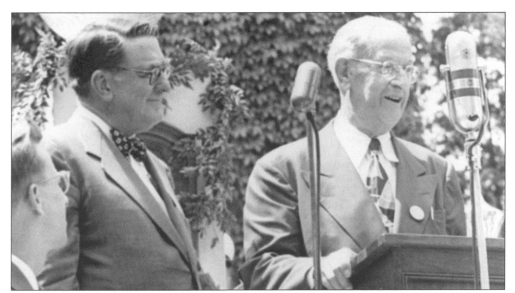

NICHOLS AT HALL OF FAME. After he retired, Nichols sold movies and owned a cinema in Kansas City with former ballplayer Joe Tinker. He also owned a large bowling alley there and even won a major championship at the age of 64. A gentleman in an age of rowdyism, he had a number of backers for his election to the Baseball Hall of Fame, including Ty Cobb, sportswriter Grantland Rice, and Hall of Fame Director Bob Quinn. Nichols was elected to the Hall in 1949, the same year that another former Cardinal pitcher, Mordecai Brown, was chosen. Nichols is seen here (on the right) accepting his plaque from Branch Rickey. (Courtesy of the National Baseball Hall of Fame Library, Cooperstown, New York.)

JACK TAYLOR. He was surrounded by controversy during much of his career and is remembered for setting a pitching record that will never be broken. A heavy gambler and drinker, he was suspected of and investigated for "throwing" games, though finally exonerated. He was one of the National League's best pitchers at the time: he won 20 games in both 1902 and 1903 and led the league in earned run average in '02. Taylor did win 35 games in his two full seasons with the Cardinals. From June 1901 until August 1906, Jack Taylor started *and completed* 188 straight games, including 18- and 19-inning contests. He was never relieved in any of his starts, though he himself appeared in relief in some games (he finished all those games too). (Courtesy of Transcendental Graphics.)

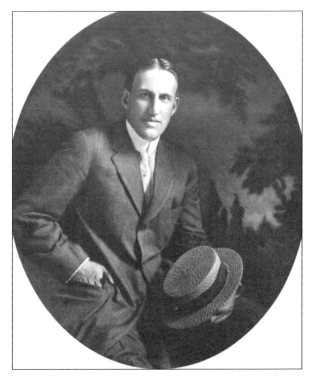

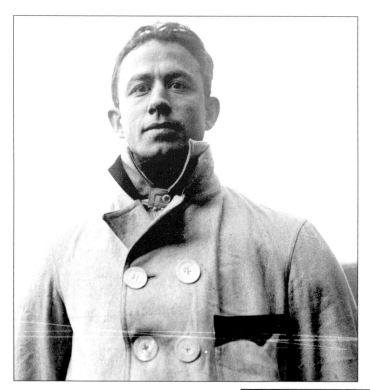

"THE YIDDISH CURVER." One of the first Jewish ballplayers, Barney Pelty spent virtually his entire 10-year career with the Browns. "The Yiddish Curver," born in nearby Farmington, was the team's workhorse from 1904 to 1907, with an average of more than 270 innings a year. He had a winning record only one of those seasons, but the Browns were not winning a lot of games those years either. He ranks among the Browns' career leaders in many categories. (Courtesy of the Chicago Historical Society.)

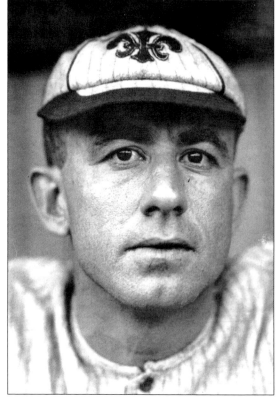

BARNEY PELTY. He came up late in the 1903 season and beat star pitchers Bill Dinneen and Bill Donovan in his first $2\frac{1}{2}$ weeks. His 1.59 earned run average in 1906 was second only to Doc White of the White Sox. Two years later the Browns came so close to the pennant, yet injuries limited Pelty to only 122 innings. Had the Browns gotten the usual 270 innings from him, with another 15 or 20 starts, where would they have finished? He pitched for the Browns in the first game in Chicago's new Comiskey Park, on July 1, 1910, and he beat spitballer Ed Walsh, 2-0. In 1912, Browns' manager George Stovall wanted "new blood" for the team and sold Pelty to Washington. That was his last year in the bigs. (Courtesy of the Private Collection of Dennis Goldstein.)

EMMET HEIDRICK. From a prominent and wealthy Pennsylvania family, Heidrick was known as the best-dressed player of his day. Alfred H. Spink called him "one of the most lovable characters baseball has ever known." He was also a ballplayer, and a good one. A career .300 hitter, he was part of the great all-.300 outfield of the Cardinals of 1900–1901 (along with Jesse Burkett and Patsy Donovan). Only Donovan, the Cardinal manager, stayed with the team after 1901, while the other two men moved on to the Browns. Heidrick left baseball after the 1904 season, to go into the contracting business. The Browns lured him back late in the 1908 season, as they were fighting for the pennant. But Heidrick was out of shape and hit only .215. He died from influenza just eight years later. (Courtesy of the National Baseball Hall of Fame Library, Cooperstown, New York.)

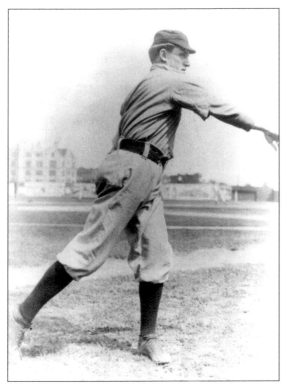

FRED GLADE. He won 18 games for the Browns in his rookie season of 1904 and lost 25 games for them the following year, tops in the league. Both years, his earned run average was below 3.00. In July 1904 he struck out 15 Senators, a mark that Christy Mathewson would top in a game against the Cardinals' pitcher-manager Kid Nichols late in the season. In early 1908 the Browns sent Glade to the New York Highlanders in a big trade that helped spark St. Louis that year. He had a sore arm and appeared in only five games for New York, with no wins. That, combined with his father's large flour milling business, drew him away from baseball at the end of the season. "Lucky," as he was nicknamed, was a millionaire from the family business. "Lucky" also holds the all-time single-season record for Browns' losses with 25. (Courtesy of Brace Photo.)

23

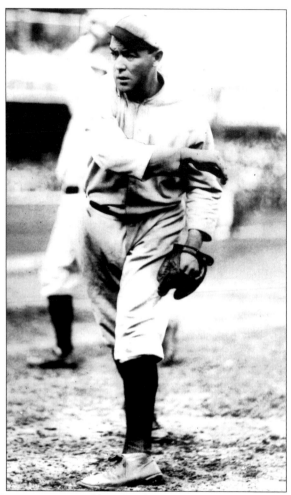

ARTHUR "BUGS" RAYMOND. "He seldom finished anything but a drink." A spitball pitcher of enormous talent and an equally large thirst for alcohol, he had two fine seasons when he stayed mostly sober—1908 for the Cardinals and 1909 for the Giants. His game then deteriorated rapidly, and his career ended in 1911 at the age of 29. A year later, his life ended in a barroom brawl. An autopsy showed he died of a skull fracture from a baseball bat.

> *Sometimes it seemed like the more he drank, the better*
> *he pitched. They used to say he didn't spit on the ball: he*
> *blew his breath on it, and the ball would come up drunk.*
> —Teammate Rube Marquard, *The Glory of their Times*

He joined the Cardinals in 1907, and the following year was one that only a good pitcher on a bad team can have: a sparkling 2.03 earned run average with a league-leading 25 losses. Manager John McCloskey coaxed 324 innings out of him, in part by letting his hurler drink. The Giants then got "Bugs," so named for his erratic behavior under the influence, as compensation in the Roger Bresnahan deal. Their manager John McGraw liked to think he could "save" wayward players. Raymond gave him a good 1909: a record of 18-12 with a 2.47 earned run average. The next two years were difficult; the problems with alcohol increased, and Raymond's performance dropped off. (Courtesy of the Mercantile Library/UMSL.)

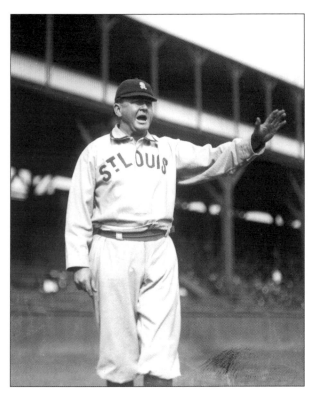

JOHN MCCLOSKEY. "Honest John" was a revered and respected figure in the early days of baseball. A Louisville batboy in 1876, he went on to manage more than 40 teams and organize a number of leagues, including the Texas League. Alfred Spink called him "Columbus," for discovering so many great players. Unlike Connie Mack, McCloskey's long career was mostly in the minor leagues. He had little success as a major league manager: 1895–1896 in Louisville (last place), and 1906–1908 in St. Louis (two last place finishes and a 7th place, 63 games out of first place). When he came to the Cardinals, McCloskey made many personnel moves, including the addition of Ed Konetchy, Bobby Byrne, and Bugs Raymond. Yet the team still lost 304 games in his three seasons at the helm. (Courtesy of the Chicago Historical Society.)

CHARLES MORAN. "Uncle Charley" had a unique career as a player and an umpire, and in both baseball and football. He appeared in three games as a Cardinal pitcher in 1903. In 1908, after his arm had gone dead, he returned as a catcher, hitting .175. As the manager of Dallas in the Texas League in 1903, he gave Branch Rickey his first pro job, signing the catcher despite knowing that Rickey would not play on Sundays. Moran went on to a very successful career as a football coach at a number of schools, including Texas A & M and Bucknell. Moran was also a respected National League baseball umpire for more than 20 years. His signature saying was, "It ain't nothin' 'til I call it." (Courtesy of Michael Mumby.)

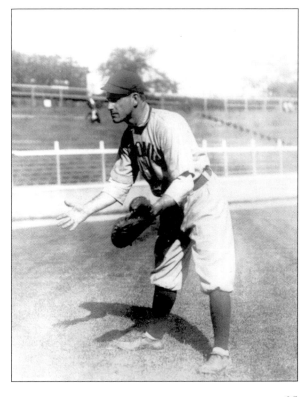

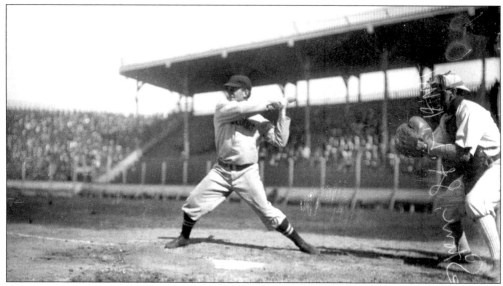

A Unique Batting Stance. George Stone led the league in hits his first year and then had a spectacular 1906: he led the league in batting average, on-base percentage, and slugging average (.358, .417, .501). After two more good seasons, injuries hampered his play, and 1910 was his final year in the bigs. His hitting style generated much discussion; critics said it reduced mobility because he was so "anchored." Seen here in this image, Stone held his bat above his shoulders, spread his legs wide apart with his right foot far forward, and swung at the ball at the last moment. (Courtesy of the Chicago Historical Society.)

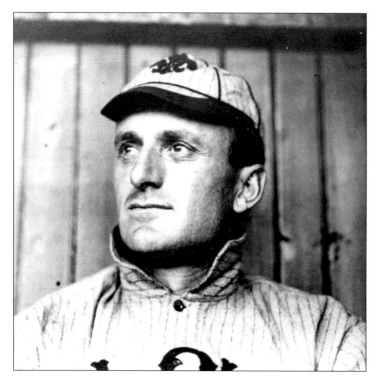

George Stone. The Browns acquired the rookie in an early 1905 trade for an aging Jesse Burkett, and Stone had a short yet impressive career. A well-read and soft-spoken man who played the violin, "Silent George" was competitive enough on the field that he often slid into first base. (Courtesy of the National Baseball Hall of Fame Library, Cooperstown, NY.)

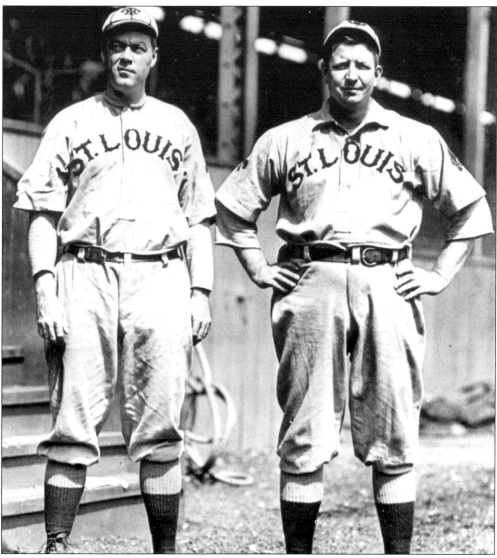

BILL DINNEEN AND JACK POWELL. Between 1900 and 1904, Dinneen (left) won 20 games four times for the Boston Braves and Red Sox, teaming up with Cy Young to lead the Sox to the 1903 and 1904 AL pennants. The 6'1" "Big Bill" ended his playing career with the Browns, 1907–1909. His 14-7 comeback season of 1908 helped the Browns contend for the pennant. That was also the year he posted the lowest earned run average of his career, 2.10. In 1909, he began a 29-year career as a respected American League umpire. Standing on the right is another hurler from that fine 1908 Browns' rotation, Jack Powell. He was one of the Cardinals' stars who jumped to the Browns in 1902. Powell was equally effective with both teams: 36 wins with the 1900–1901 Cards and 37 wins with the 1902–1903 Browns. He was traded to New York in 1904, but returned the following year to the Browns and won another 80 games over the next few seasons. He failed in a comeback attempt with the team in 1918; many people felt it was a publicity stunt for his saloon. Powell is one of the Browns' career leaders in many pitching categories. He is one of only two pitchers in baseball history with 200-plus wins and *more losses than* wins. The other is Bobo Newsom, also a Brown during his career. (Courtesy of the Western Reserve Historical Society, Cleveland, Ohio.)

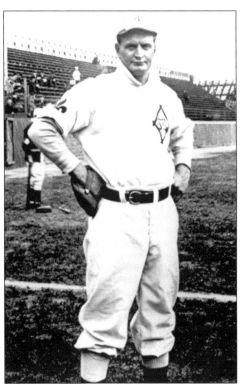

RUBE WADDELL. One of baseball's zaniest characters, he was also a great pitcher—when he kept his impulsive behavior under control. He won 193 games, and 50 of them were shutouts. From 1902 to 1905, Waddell was a star pitcher on Connie Mack's great Philadelphia Athletics' teams, when his record was 97-52. More impressive were his 1,148 strikeouts in those four seasons. Only three men since have exceeded his mark of 349 strikeouts of 1904: Nolan Ryan (383 and 367), Sandy Koufax (382), and Randy Johnson (364 and 372). Yet "Rube" also wrestled alligators, chased fire trucks, went fishing on game days, and became increasingly erratic over the next two years, though he again led the league in strikeouts both times. Connie Mack gave up on Waddell, more over his behavior than his baseball performance, and sold his pitcher to the Browns for $5,000 after the 1907 season. Waddell responded with a terrific year in 1908, winning 19 games with a 1.89 earned run average. (Courtesy of the National Baseball Hall of Fame Library, Cooperstown, New York.)

RUBE AND MASCOT. He then began to fade, winning 11 games in 1909 and only three more games after that. He contracted health problems after spending hours in icy waters piling sandbags to combat a Kentucky flood. He died of tuberculosis on April Fools' Day, 1914. He was elected to the Baseball Hall of Fame in 1946. Waddell loved dogs and is seen here with the Browns mascot (spelled "masot" on his cape). (Courtesy of William Trefts/Missouri Historical Society, St. Louis.)

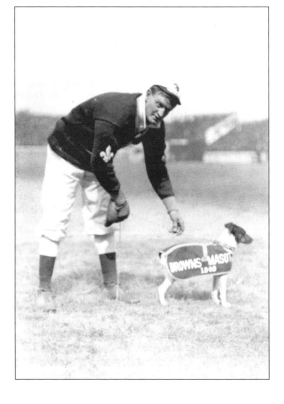

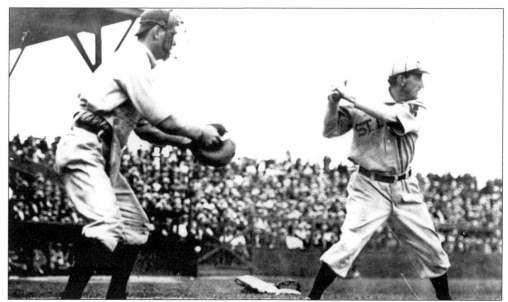

BOBBY WALLACE. He played shortstop in St. Louis for more than 20 years, and his baseball career spanned seven decades. Wallace's best year was one of his few with the Cardinals, in 1901, when he hit .324. A career .268 hitter, he is most remembered for his fielding. He had great range and a tremendous arm; he still ranks high in career assists and chances per game. When Bob Hedges signed him in 1902 for $32,500 for five years, it was the biggest contract in baseball. In 1911, after the Lajoie controversy had eliminated the team's manager, John O'Connor, Wallace reluctantly became the Browns' skipper and gladly gave it up to George Stovall the next year. He ended his playing career in 1917–1918 with the Cardinals. He was a Cincinnati scout from 1927 until his death in 1960. In 1953, he became the first American League shortstop elected to the Baseball Hall of Fame. (Courtesy of the National Baseball Hall of Fame Library, Cooperstown, New York.)

DANNY HOFFMAN. A promising young outfielder with the Athletics, he suffered a serious beaning from pitcher Jesse Tannehill in 1904, which permanently affected his sight in one eye. He was a speedster on the basepaths, averaging 30 stolen bases a year from 1905 to 1909, despite averaging only 114 games per season. He led the league in swipes with 46 in 1905. After a couple of years with the New York Highlanders, he came to the Browns in the big February 1908 trade that sent Fred Glade and Charlie Hemphill to New York. Hoffman became a regular outfielder for the Browns in their fine 1908 season. He spent four years in St. Louis. A career .256 hitter, he never came close to the .299 he hit with Philadelphia in 1904. (Courtesy of Michael Mumby.)

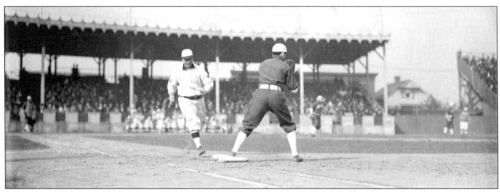

ACTION SHOT, SPORTSMAN'S PARK 1907. The world champion Chicago White Sox are visiting Sportsman's Park in 1907. The Browns' Tom Jones is running to first base, as the White Sox's Jiggs Donahue is waiting for the throw. Jones may have been the prototypical "average hitter." His career batting average was .251. In all his seven full seasons, he hit between .242 and .259—never higher, never lower. Here is Sportsman's Park as it looked in 1902, when the Browns started; there is no upper deck to the grandstand. Owner Robert Hedges undertook a major re-lay, remodel, and expansion of his stadium, including a double-decked grandstand, after the profitable 1908 season. Even after that remodel, the grandstands from first to third base did not extend continuously down the lines. Only with Phil Ball's remodel of 1925–1926 did the stands continue from foul pole to foul pole without a break. (Courtesy of the Chicago Historical Society.)

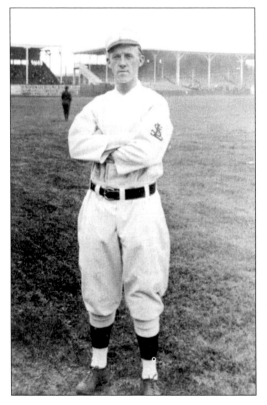

BOBBY BYRNE AND THE KERRY PATCH KIDS. He grew up in the Kerry Patch of St. Louis, around 17th and Cass, where he starred in club soccer and sandlot baseball. Jimmy Burke described the neighborhood as "almost entirely Irish, and we were a fighting bunch of micks." A number of ballplayers came out of there, including a couple of future St. Louis Browns, Lefty Leifield and Jack Tobin. A smallish third baseman, Byrne broke into the bigs with the Cardinals in 1907. Late in the 1909 season, he was traded to the Pittsburgh Pirates, where he played alongside Honus Wagner as the team won the pennant and World Series. The following year, Byrne hit .296, led the league in doubles, and tied for the lead in hits with Wagner. He remained in the league until 1917, with a reputation as a fine defensive player. He led the National League third basemen in fielding percentage two times (1912 and 1915), yet his bat never came close to that 1910 performance. (Courtesy of *The Sporting News*.)

JOE SUGDEN. "He threw out a right hand that looked like a weather vane. Fingers were pointing in every direction. Shaking hands with him felt like grabbing a sack full of peanuts." Joe Garagiola, in *Baseball is a Funny Game*, on meeting Joe Sugden when Joe G. was 13 years old. His baseball career spanned 66 years as a player, coach, and scout, many of those years with the Cardinals. Primarily a catcher, he played many positions. He was one of the catchers on the Browns in their first four years. In his final year with the team, 1905, he befriended a young catcher who appeared in only one game for the Browns that year. That rookie never forgot Sugden and later hired him as a coach and scout. That youngster was Branch Rickey, and Sugden worked for him both on the Browns and the Cards. Sugden was a Cardinal coach from 1921 to 1925, and he missed out on the 1926 championship when he went over to coach the Phillies that year. Yet he shared in plenty of Cardinal victories: he re-joined the team as a scout in 1928 and served in that capacity until his death in 1959. (Courtesy of the *The Sporting News*.)

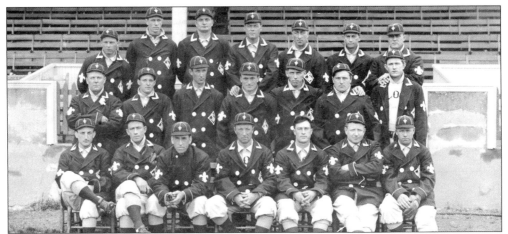

1908 St. Louis Browns. The Browns prepared for a serious run at the American League pennant, with two veteran pitchers added to the team—Rube Waddell and Bill Dinneen (back row, third and fourth from left). Though both were near the end of their playing careers, they won 33 games for the Browns that year. Manager Jimmy McAleer is in the middle of the front row, with 1906 AL batting champ George Stone directly behind him (middle of middle row). Bobby Wallace is in the front row (far left), with Browns' coach "Rowdy Jack" O'Connor directly behind him (far left of middle row). "Handsome Harry" Howell (third from left) and pitcher Jack Powell (second from right) are in the front row. (Courtesy of the David Eskenazi collection.)

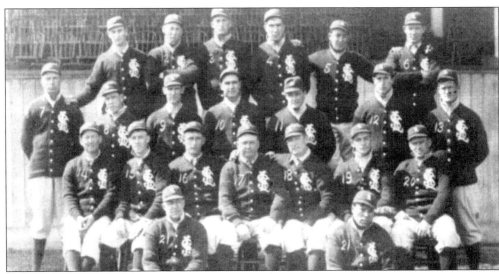

1908 St. Louis Cardinals. Manager John McCloskey made a number of personnel changes in his tenure as manager (1906–1908), yet the weak Cardinals got worse, going from 98 to 101 to 105 losses. In the back row (third, fourth, and fifth from left) are rookie Slim Sallee, youngster Ed Konetchy, and pitcher Bugs Raymond. On the far right of the middle row is "Red" Murray, a great defensive outfielder and one of the Deadball Era's power hitters. After the '08 season, he went to the New York Giants in the Roger Bresnahan deal and led the league with seven home runs in 1909. A couple of other players of note here are St. Louis native Bobby Byrne (second row, second from left) and Fred Beebe (top row, far left). Beebe broke in with the 1906 Cubs and sported a 6-1 record when he was traded to the Cardinals for Jack Taylor. He finished the season with a 15-10 record and led the National League in strikeouts with 171.

TWO

Changing of the Guard

1909–1912

Roger Bresnahan energized the Cardinals, at the box office more than in the standings. Attendance rose nearly 50 percent in 1909, though the team still finished 56 games out of first place. To acquire their new manager, they had to give up some of their best players, including outfielder Red Murray and pitcher Bugs Raymond.

Bresnahan's contributions on the playing field were limited. The previously sturdy catcher was hampered by injuries during his stint in St. Louis, playing in an average of only 72 games in the next four seasons (after averaging 117 games between 1903 and 1908). The Cardinals still had two emerging stars: pitcher Slim Sallee, who would win more than 100 games for the team, and first baseman Ed Konetchy, who was becoming one of the best all-around first basemen in baseball.

For the Browns, this was a transitional period. The 1909 season was a repeat of 1903: the team did not build upon the success of the previous year. This time, Jimmy McAleer had enough, and the only manager the Browns had known moved on at the end of the season. The team had three managers in the next three seasons, and two of them (Jack O'Connor, George Stovall) left amid controversy at the urging of American League president Ban Johnson. In between, the city's most famous player, Bobby Wallace, took over as manager. None of these men came close to a winning record; the Browns lost more than 100 games all three years.

For the Cardinals, these were noteworthy years. Before the 1910 season, Bresnahan swung a trade that brought a scrappy and brainy second baseman named Miller Huggins to town. A year later Stanley Robison died (his brother Frank had passed away in 1908), and his niece Helene Britton inherited the team. For the next six years, the male bastion of baseball owners had a female in their midst, the accidental owner the press called "Lady Bee."

In her first year as owner, Lady Bee's Cardinals were in the thick of the 1911 pennant race well into the summer, and the team drew the most fans in their history, 448,000. They would not surpass the mark for another decade. Ironically, the team was now in better shape financially than it had been for years with her father and uncle at the helm. Lady Bee rewarded Bresnahan with an unusually lucrative contract: a five-year deal at $10,000 a year plus 10 percent of the profits. During the next year, he often approached her about selling the club to him and a group of investors, but was rebuffed.

As so often happened with St. Louis baseball, a team was unable to sustain, let alone improve upon, a strong season. 1912 was a major disappointment, as the Cardinals fell to last place in early May and 30 games out of first place by early July. They finished in sixth place, 41 games behind the New York Giants. Attendance was off almost 50 percent from the previous year and was coupled with Lady Bee's ongoing legal bills to settle her uncle's estate. The Cardinals were down in the standings and back in the financial squeeze that they had grown so accustomed to. With this backdrop, Lady Bee and her newly signed manager clashed repeatedly. Their

showdown was a classic "No lady is going to tell me how to run a ballclub" versus "That's no way to talk to a lady" (certainly not a lady owner) conflict. She fired Bresnahan shortly after the 1912 season (eventually buying out the balance of his contract for $20,000) and appointed Miller Huggins as manager a few days later.

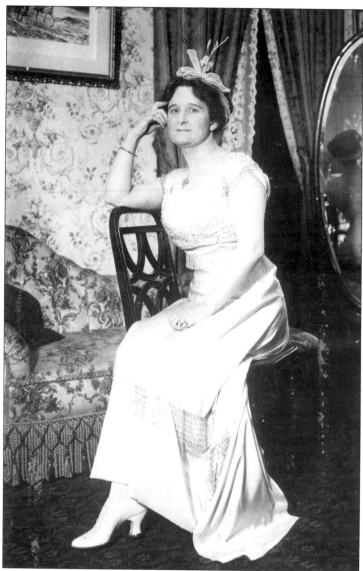

HELENE BRITTON. Her father Frank Robison died in 1908, and when her uncle Stanley Robison died without children in March 1911, she inherited the Cardinals. The first female owner of a major American sports franchise, Britton was active both in the women's right movement (a suffragette) and in the running of her ballclub. Her first season as owner would be her best financially—the excitement of the 1911 pennant race helped attendance and profits. (Courtesy of the Library of Congress, Prints and Photographs Division.)

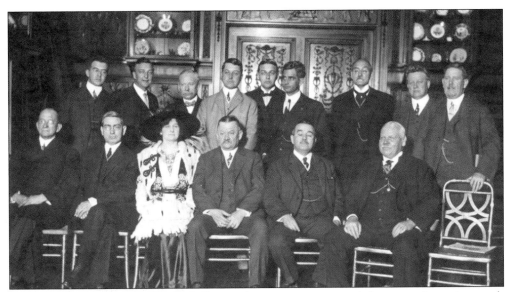

NATIONAL LEAGUE OWNERS. Lady Bee made it a point to attend the owners' meetings each year and became a colorful addition to both the discussions and annual photographs. To her right is Gary Herrmann, the owner of the Cincinnati Reds and president of baseball's governing body, the National Commission. (Courtesy of Culver Pictures.)

OPENING DAY 1912 AT ROBISON FIELD. After the Cardinals' improved showing in 1911, St. Louis eagerly anticipated the start of the 1912 season. Opening Day was warm and sunny, and a large crowd turned out to see the hometown club host the Pittsburgh Pirates. Fans surrounded the Cardinals as they went through their pre-game workouts. They went on to beat Pittsburgh, 7-0, behind Bob Harmon's pitching. While the Cards started the season with three straight wins, they quickly faded and finished in sixth place, with a disappointing record of 63-90. It was Roger Bresnahan's final year as Cardinal manager. (Courtesy of William Trefts/Missouri Historical Society, St. Louis.)

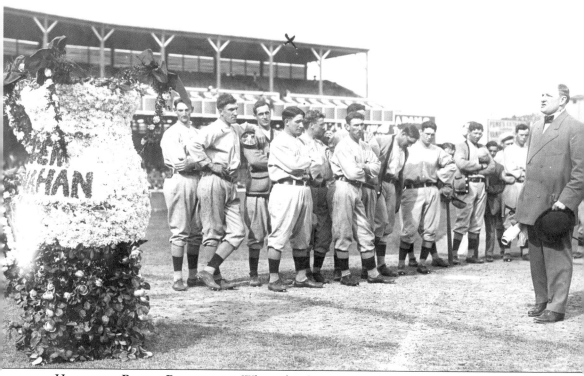

HONORING ROGER BRESNAHAN. When the St. Louis Cardinals acquired him as player-manager in December 1908, the baseball world took notice, and St. Louis fans were thrilled. One of the best players on the great New York Giants and one of the game's finest catchers was coming to St. Louis. The team that had averaged 100 losses in the past four years would now be led by a dynamic personality who did not tolerate losing.

A blunt and temperamental battler, he did have to deal with losing in St. Louis. The Cardinals improved by only five wins in 1909, and Bresnahan was often ejected by umpires. Still, he excited fans, and the team drew well. Two factors worked against his success in St. Louis. First, he provided the team with only limited help on the field. Though he was only 29 when he took over, he battled a series of injuries that limited his playing time the next few years. Second, the New York Giants and their manager John McGraw had extracted a heavy price in talent from the Cardinals when they let Bresnahan pursue the managerial opportunity.

When he returned to New York on May 24, 1909, Bresnahan (fourth from left) was honored in a pre-game ceremony and presented with a horseshoe of flowers and a floral loving cup by legendary 19th century baseball figure John Montgomery Ward (foreground, right). Afterwards, Bresnahan made it a perfect day, at least for his new team, if not for his hosts. The Cardinals beat the Giants and Christy Mathewson, their nemesis for years, by the score of 3-1.

A year later, Bresnahan pulled off a big trade with Cincinnati that brought Miller Huggins to St. Louis. The feisty second baseman added a spark to the lineup with his high on-base percentage and speed on the basepaths. In 1912, perhaps perceiving a threat to his job, Bresnahan tried to trade Huggins away, but owner Helene Britton vetoed the deal. Just a few months later, she fired Bresnahan and replaced him with none other than Miller Huggins. (Courtesy of Culver Pictures.)

PLAYER-MANAGER. Bresnahan never came close to greatness as a manager. None of his St. Louis teams finished in the first division, and he had only one more opportunity to manage in the majors, with the Chicago Cubs in 1915. Bresnahan then returned to his hometown of Toledo, where he owned the minor league team there for eight seasons and managed it from 1916 to 1920. He returned to the New York Giants as a coach from 1925 to 1928, when he worked with a young pitcher by the name of Carl Hubbell. Remembered as the man who invented shin guards, Bresnahan was elected to the Baseball Hall of Fame in 1945. (Courtesy of the Library of Congress, Prints and Photographs Division.)

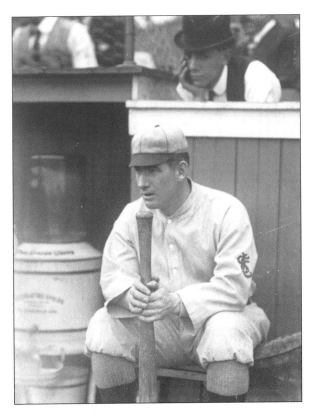

DICK KINSELLA. A long-time scout and confidant of John McGraw, he scouted for the Cardinals for a few years, breaking off his relationship with the team when Roger Bresnahan was fired late in 1912. Kinsella worked primarily for the Giants, the team for whom he found so many players— from Marquard to Merkle, from Crandall to Youngs. He recommended Ed Konetchy to the Cardinals, but only after the Giants didn't sign him. The new owners of the Yankees hired him in 1916. Two years later, when Miller Huggins came to the Yankees, Huggins brought his scout and close friend Bob Connery to New York, and Kinsella ended up back with the Giants. "Sinister Dick" was a name that stuck to this shrewd veteran scout. He is seen here in the dark suit, reunited with McGraw on the left and Bresnahan on the right in the 1920s. (Courtesy of the Burton Historical Collection, Detroit Public Library.)

HARRY HOWELL. An expert spitball pitcher, "Handsome Harry" was the Browns' leading pitcher from 1904 to 1908. While he had a losing record in this time span (77-90), the Browns were a weak team in most of these years. His earned run average was between 1.89 and 2.19, well below the league average. In his previous five seasons, with Brooklyn, Baltimore, and the New York Giants, before he mastered the spitter, his earned run average was between 3.53 and 4.12. Howell scouted and coached for the Browns in 1909 and 1910, when he had injuries, including a broken arm, and pitched very little. His name is forever linked with that of Browns' manager and catcher Jack O'Connor (following page) for their roles in the Napoleon Lajoie batting controversy of 1910. (Courtesy of the Burton Historical Collection, Detroit Public Library.)

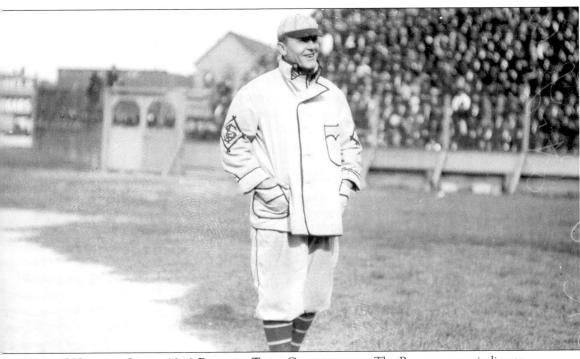

JACK O'CONNER & THE 1910 BATTING TITLE CONTROVERSY. The Browns were winding up the season at home against Cleveland in an apparently inconsequential double-header. The Indians' popular second baseman Lajoie had been fighting with Detroit's Ty Cobb for the batting title. There was also a new Most Valuable Player award, the Chalmers award, associated with the title, which provided the winner with a Chalmers auto.

There was strong sentiment for the unpopular Cobb *not* to win, though he had a seemingly insurmountable lead going into the last day of the season. Cobb sat out that day. He had won the batting title the last three years, would win it the next five years, and figured this one was "in the bag." Lajoie had won three batting titles himself a few years earlier.

After Lajoie got a triple his first time up, Browns' manager Jack O'Connor (seen above) had his rookie third baseman Red Corriden play very deep. The rest of the day Lajoie, apparently not party to this plan, took advantage of it by laying down bunts, which he beat out for hits. Lajoie was 36 years old and was not fast, yet he beat out all these rollers. One of the infield hits was initially ruled an error, and coach Howell visited with the official scorer in the press box a number of times. There was even a note sent to the box, with the offer of a new suit to the scorer if he handled the matter as Howell and O'Connor saw it.

When the games ended, Lajoie had gone 8 for 8 and apparently won the title and the auto. This batting race still had a couple more twists. When the league reviewed the season's numbers, it was determined that Cobb actually had won, by the slightest of margins. Then, years later, a researcher discovered that Cobb had been incorrectly credited for some hits during the season, and that Lajoie really had won. At any rate, the Chalmers Motor Company tried to calm the controversy and benefit from the publicity by awarding two cars, one to Cobb and one to Lajoie.

American League president Ban Johnson was outraged by the Browns' approach to Lajoie's at-bats and conducted an investigation. O'Connor somewhat weakly explained that he didn't want his young third baseman to be hurt by screaming liners off of Lajoie's bat; so he stationed Corriden deep. Corriden was found innocent since he was merely a rookie being told where to play. Johnson felt otherwise about the other two men and convinced Hedges to fire them. Howell did umpire in the Federal League in 1915, but never again coached in the bigs. (Courtesy of the Chicago Historical Society.)

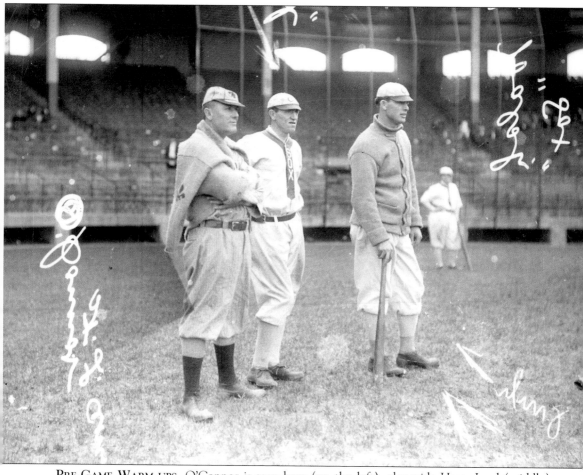

PRE-GAME WARM-UPS. O'Connor is seen here (on the left), alongside Harry Lord (middle) and Ed Walsh of the Chicago White Sox late in that 1910 season.

O'Connor's 21-year career in the big leagues ended with the Lajoie batting title of 1910, and it may have been driven by O'Connor's intense dislike of Ty Cobb. O'Connor grew up in St. Louis' Goose Hill district, where he starred on the semi-pro Shamrocks with his childhood buddy Patsy Tebeau and with Jimmy Burke. Tebeau managed the Cleveland Spiders for the Robisons in the 1890s, where O'Connor had some strong years. "Rowdy Jack" was a tough guy, but Goose Hill was a "Run or Fight" place in the 1880s. A fierce competitor, he was suspended many times. He was also known as "Peach Pie," for the name of another semi-pro team that he played on.

O'Connor had been involved with other controversies. In 1902, he lured some of his Pittsburgh Pirate teammates to the new American League. He was suspended for doing so, but not before he succeeded in getting star pitchers Jack Chesbro and Jesse Tannehill to jump to the New York Highlanders, the team O'Connor himself joined in 1903.

After the Browns fired O'Connor late in 1910, he sued for his $5,000 1911 salary and won. In 1913 he managed the minor league St. Louis Terriers. During one of his outbursts that year, he punched an umpire and broke his jaw. O'Connor then began scouting for the Terriers, working against the very man for who he did such work a decade earlier, Ban Johnson. O'Connor's saloon, at 8th at Pine, which he co-owned with brother-in-law Jack Powell, was a local St. Louis landmark for many years. (Courtesy of the Chicago Historical Society.)

HARRY "SLIM" SALLEE. The pitching star of the Cardinals from 1909 until he was sold to the New York Giants in July 1916, he won more than 100 games for St. Louis. Sallee was a tall (6'3"), lanky southpaw with terrific control and a "crossfire" pitch similar to that of Eddie Plank. He was one of the team's starters, yet he often appeared in relief too. Sallee's fondness for liquor resulted in several unannounced absences from the team. Roger Bresnahan suspended Sallee more than once for "disappearing" on the team. Slim's easygoing personality and affinity to alcohol probably prevented a very good pitcher from being a great one. (Courtesy of the Private Collection of Paul Sallee.)

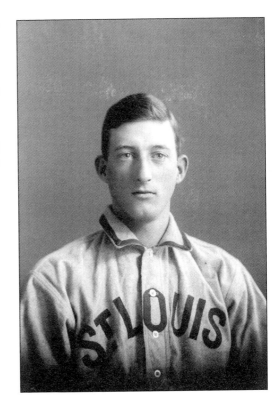

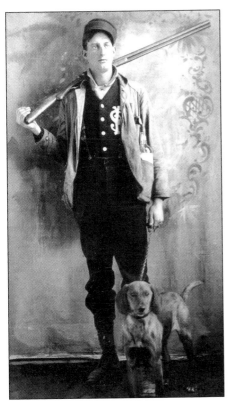

SALLEE AND HUNTING DOG. From 1909 to 1919, his earned run average was below 3.00 each year, including 2.10 in 1914. In 1916, Sallee forced a sale to the Giants by threatening to retire. The Brittons needed money to run the club (they were still recovering from two years of the Federal League), and so they sold one of the league's best pitchers for $10,000. Sallee then played on three pennant winners in the next five years: the New York Giants (1917, 1921) and the Cincinnati Reds (1919). In 1919 he had more wins (21) than walks (20), a reflection of his remarkable control. Slim Sallee is seen here ready to go hunting, with his dog at his side and his whiskey bottle in his pocket. (Courtesy of the Private Collection of Paul Sallee.)

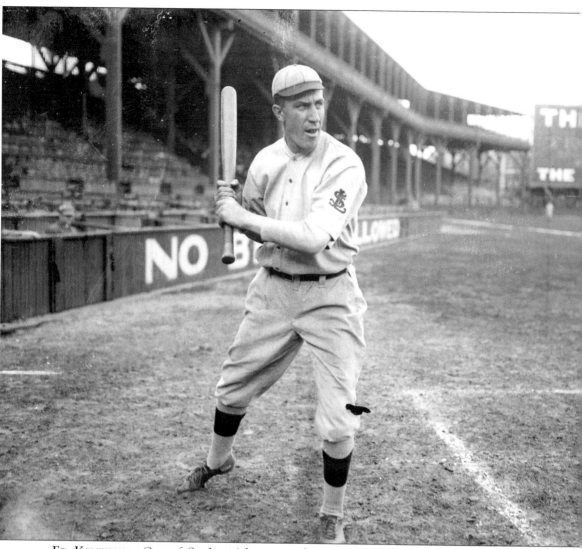

ED KONETCHY. One of St. Louis' biggest early stars, "Koney" was arguably the best first baseman of his day, a great all-round player. He was a slashing line-drive hitter who was also strong in the field. Konetchy was an imposing figure at the plate, the way he held the bat—it almost looked like a little stick in his hands as he sprayed line drives. Cardinal manager Jack McCloskey signed him in 1907. Koney was a candy-maker in LaCrosse, Wisconsin, where he was born. Between 1908 and 1913, he averaged almost 150 games a year for the Cardinals, hit over .285 four times (.300 twice) and stole an average of more than 20 bases a year. Early in his career, the Greek community honored him before a game in Pittsburgh. Ed couldn't understand a word they were saying during the ceremony. They had thought he was Greek; he was actually Polish, or, in his words "a Bohemian." (Courtesy of the Chicago Historical Society.)

"DEADBALL SLUGGER." Just how good would Konetchy have been, had he played most of his career in the Lively Ball Era, after 1919? One can only wonder. In 1925, at the age of 40, with the Fort Worth Panthers of the Texas League, he hit .345 with 41 home runs and 166 runs batted in. "Big Ed" (6'2 1/2", 195 lbs) still ranks second in career putouts for first basemen. He's just ahead of Eddie Murray and behind the leader Jake Beckley, whose last season was with the Cardinals in 1907, when Koney was a rookie. (Courtesy of the Private Collection of Dennis Goldstein.)

BOB HARMON. From 1909 to 1913, he and Slim Sallee anchored the Cardinal pitching rotation: Harmon with 68 wins, and Sallee with 67. Harmon's 23 victories in 1911 were the most for a St. Louis hurler since Jack Harper had that many in 1901. That mark would stand until Urban Shocker won 27 games in 1921. After the 1913 season, in which he had 21 losses, Harmon was traded to Pittsburgh with Ed Konetchy. Though only 26 years old at the time, Harmon had only two more effective seasons. He sat out the 1917 season over a contract dispute and had an unsuccessful comeback in 1918. "Hickory Bob," who enjoyed dancing and playing the fiddle, later became a prominent Louisiana dairy farmer. (Courtesy of William Trefts/Missouri Historical Society, St. Louis.)

43

JIMMY "PEPPER" AUSTIN. He didn't reach the bigs until he was almost 30 years old. He appeared in a game two decades later, when he was almost 50. Born in Wales, Austin was a weak-hitting, but slick-fielding third baseman. He led the league in various defensive categories a number of times. His first season in St. Louis, 1911, was a reminder of the complexity of evaluating fielding: he led the league's third basemen in errors, but also in assists, double plays, and putouts. (Courtesy of the Walter P. Reuther Library, Wayne State University.)

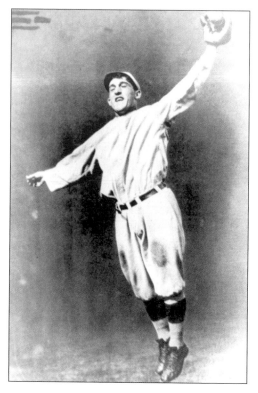

ARNOLD HAUSER. He was a promising young Cardinal shortstop whose career and life were haunted by tragedy. "Peewee" was 5 foot 6, 145 pounds and was described as sensational in 1911 and 1912. Typical was the comment in Spinks' *The National Game*, describing the little infielder as "one of the cleverest and fastest short fielders shown in big league circles in years." The numbers really didn't reflect that brilliance—he hit .241 and .259 those years, with fielding percentages of .918 and .934. In 1913, an almost unbelievable string of heartbreak and misfortune hit Hauser: he hurt his knee, his mother committed suicide, his father died tragically, his two little children were burned to death, and... his wife died. The Cardinal shortstop was institutionalized—one account said he had been gripped by a "religious mania." He tried a brief comeback with the Chicago Whales in 1915 but hit only .204 in 23 games. He spent the last years of his life as a chef in the Mercyville Sanitarium in Aurora, Illinois. (Courtesy of Brace Photo.)

FRANK CORRIDON. Corridon was a pitcher who is often credited with discovering the spitter. In 1902 with Providence, he was throwing the sharply breaking wet ball with another player named George Hildebrand, who in turn later showed it to another pitcher named Elmer "Spitball" Stricklett. In 1904, Stricklett was on the Chicago White Sox, where he taught the spitter to a young pitcher named Ed Walsh. Walsh later became the master of that pitch. In early 1910 Corridon went to the Cardinals in the Miller Huggins trade. 1910 was his final season in the bigs, which he left with a 70-67 record. It is probably more accurate to say that he helped re-discover the spitter in the 20th century. Both common sense and evidence suggest that the pitch was thrown earlier. (Courtesy of the Private Collection of Dennis Goldstein.)

BILL BAILEY. After posting a 4-1 record for the 1907 Browns at the age of 18, Bailey never again had a winning record in his 11-year career. His 3-18 record for the 1910 Browns symbolizes the difficulty the franchise had during this time period. From 1910 to 1912, the Browns lost more than 100 games each year.

A pitcher for both the Browns and the Cardinals, he made a comeback for the Cards in 1921 after leaving the Browns back in 1912. He led the Texas League in strikeouts in both 1919 and 1920 (for Beaumont), which caught the eye of Cardinal scout Charlie Barrett. (Courtesy of Michael Mumby.)

STEVE EVANS. Fred Lieb called him "one of baseball's delightful screwballs." He patrolled the outfield for the Cardinals from 1909 to 1913. He once had his clothes fall off on the field. Another time he came to the outfield with a parasol, sat on a stool, and lit a cigarette. In 1914 he jumped from the Cardinals to the Brooklyn Tip-Tops of the Federal League. His 1914 season was one of the league's best: a .348 batting average (second in the league), with a league-leading slugging percentage (.556) and triples (15). Evans' move to the Tip-Tops was just one example of the impact of the new league. Once Lee Magee joined the Feds in 1915, Miller Huggins had lost his entire promising 1913 outfield of Evans, Oakes, and Magee. Evans started with the New York Giants in 1908. Some accounts say John McGraw dealt him away because he couldn't handle Evans' antics, yet the skipper invited Evans to join him on the 1913–1914 World Tour. One explanation for this seeming contradiction is that McGraw wanted entertaining characters who would amuse the fans and keep the players loose during the around-the-world trip. Evans teamed up with another baseball comedian, Germany Schaefer, to do just that. He was also on the receiving end of the baseball that Ivey Wingo threw over the Sphinx in Egypt. (Courtesy of the Private Collection of Dennis Goldstein.)

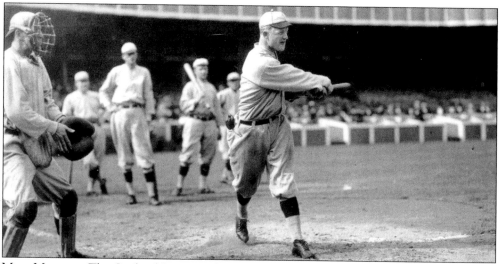

MIKE MOWREY. The Cardinals' starting third baseman from 1910 to 1913, he was a .256 hitter who scored and drove in almost an equal number of runs in his career. He had a unique fielding style, knocking the ball down and then picking it up and throwing to first base. He had terrific range in the infield during his St. Louis years. He was traded to Pittsburgh in the Konetchy-Miller deal and jumped to the Federal League with "Koney" in 1915. Mowrey ended his career with Brooklyn in 1916–1917, reaching the World Series his first season there. He later played in a wartime steel league. (Courtesy of the Private Collection of Dennis Goldstein.)

ENNIS "REBEL" OAKES. An anchor in the Cardinal outfield from 1910 to 1913, he came to St. Louis in the Miller Huggins deal. A .279 hitter in his seven-year career, Oakes jumped to the Federal League in 1914–1915 as the 30-year-old player-manager of the Pittsburgh Rebels. Like another St. Louis outfielder, Steve Evans, Oakes did not get any offers from organized baseball after the demise of the Federal League. This suggests an informal blacklisting, since both men were still on top of their game. Oakes' batting average in his last four seasons: .281, .293, .312, and .278. He did not endear himself to the American and National Leagues by raiding their clubs for Federal League players. Oakes, whose nickname reflects his southern origins, returned to Louisiana and entered the oil business after he left baseball. (Courtesy of the Burton Historical Collection, Detroit Public Library.)

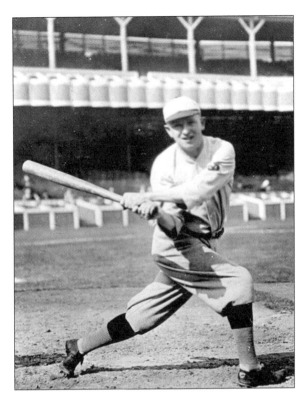

GEORGE "RUBE" ELLIS. A product of the sandlots of San Francisco, his entire major league career consisted of four years with the Cardinals, 1909–1912, and coincided with Roger Bresnahan's years as the team's manager. His batting average was remarkably consistent during those four seasons: 1909 (.268), 1910 (.258), 1911 (.250), and 1912 (.269). Ellis hailed from California and spent a number of years in the Pacific Coast League after he left the bigs. (Courtesy of Michael Mumby.)

BILL KILLEFER. He was Grover Cleveland Alexander's battery-mate in both Philadelphia and Chicago. He started and ended his major-league career in St. Louis. A career .238 hitter, he hit only .126 for the Browns in 1909–1910. Killefer stayed in the bigs for 13 years and more than 1,000 games because he was a terrific defensive backstop. He helped the Phillies to the 1915 World Series. Late in 1917, he and Alexander were traded to the Cubs (another catcher, Pickles Dillhoefer, went the other way) in a blockbuster deal, and his new team went to the World Series in 1918. After managing the Cubs from 1921 to 1925, he returned to St. Louis as Rogers Hornsby's Cardinals' coach in 1926. After Sam Breadon traded Hornsby away that fall, he offered Killefer the manager's job, but the coach refused, out of loyalty to his former boss. He stayed in town and became a coach for the Browns instead and took over as their manager in 1930. Ironically, a catcher with whom he had spent a lot of time in Chicago, Bob O'Farrell, became the Cards' skipper instead. Even more ironically, when Killefer was fired in 1933, Rogers Hornsby replaced him as manager of the Browns.

Known as "Reindeer Bill" for his less-than-blazing speed, especially later in his career, he was a central figure in the Federal League battles as a "double-jumper." Early in 1914, he signed with the Chicago Whales and jumped back to the Phils with a fat contract ($6,500 a year for three years). The ChiFeds request for an injunction was turned down by the court, which said their initial raid was immoral. League president Gilmore then used the Killefer case as a justification for going after even those players who were under contract, not simply those who were supposedly bound by the reserve clause. (Courtesy of Michael Mumby.)

MILLER HUGGINS. He was a scrappy little second baseman when the Cardinals acquired him from Cincinnati early in 1910. The trade energized his career. After an injury-plagued 1909, Huggins bounced back with a .399 on-base percentage, 34 steals, and a league-leading 116 walks. Huggins was known as "Little Everywhere" and "The Rabbit" for his hustle on the field and in the basepaths. Eight times he stole more than 25 bases, and he led the league in walks four times. Half of these achievements came after he joined St. Louis at the age of 32. In 1913, at the age of 35 and while a player-manager, he led the league in on-base percentage. Huggins gave pitchers a small, almost impossible strike zone—he crouched while at bat and did not swing at many bad pitches. He was also around 5'2", not the 5' 6" he is listed at. (Courtesy of the Boston Public Library, Print Department.)

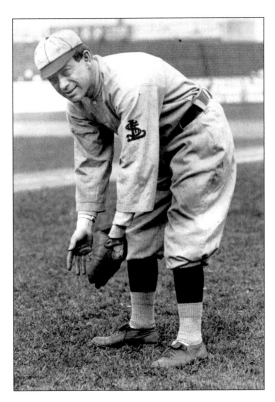

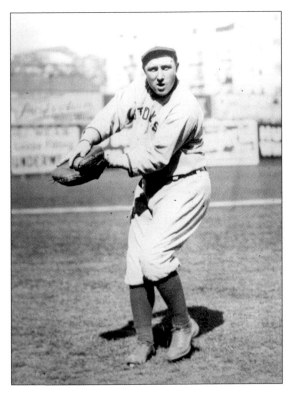

PAUL KRICHELL. He played for the Browns from 1911 to 1912. A product of the sandlots of the Bronx when semi-pro ball was big in New York City, he went on to fame as a scout and head of scouting operations for the New York Yankees. After managing Bridgeport of the Eastern League and coaching NYU baseball in the late 'teens, he joined Boston Red Sox manager Ed Barrow as a coach. When Barrow joined the Yankees after the 1920 season, Krichell followed him there. "Krich" was hired to focus on the college players and soon found one at Columbia: Lou Gehrig. Krichell stayed with the team until his death in 1957. During his tenure, he signed many future Yankee stars, from Tony Lazzeri to Whitey Ford. (Courtesy of Bruce Photo.)

THE JOSS BENEFIT GAME. On July 24, 1911, a benefit game was played for the family of Cleveland pitcher Addie Joss, who had died of meningitis earlier that year. Seen here are four of the participants in that game, three of whom had St. Louis ties. George Stovall (left), was the Cleveland manager who would manage the Browns in 1912. Jimmy McAleer (in the suit), was a former Browns' manager who came out of retirement to manage the All-Stars. Hal Chase (to right of McAleer) was the New York Highlander player-manager. Bobby Wallace (right) was the Browns' player-manager of 1911 and long-time St. Louis infielder. The All-Stars, managed by McAleer and led by Walter Johnson and Ty Cobb, beat the Cleveland Indians, managed and led by Stovall, 5-3, and raised almost $13,000 for Joss' family. Hal Chase had 17 putouts in the game. (Courtesy of Michael Mumby.)

FRANK LaPORTE. He came to the Browns in early 1911 with Jimmy Austin. LaPorte had the best year of his career in 1912, hitting .314 with 37 doubles in only 136 games. He also led the league's second basemen in assists, double plays, and errors. Yet less than a year later, he was traded to Washington. The Browns had found a replacement in their fine rookie, Del Pratt. In 1914 LaPorte jumped to the Indianapolis Hoosiers of the Federal League and led that league in runs batted in while hitting .311. Yet the following year would be his last, when his offensive performance dropped off significantly, though he had a stellar year in the field. He picked up the nickname "Pot" as much for his shape (a stocky 5'8", 175 lbs) as for a contraction of his last name. (Courtesy of the Library of Congress, Prints and Photographs Division.)

THREE

The Rise and Fall of the Federal League

1913–1915

The Federal League began in 1913 as an independent *minor* league with a distinctly Midwestern flavor (five of its six teams were from there, plus Pittsburgh). As the year progressed, it became apparent that the league's owners wanted to reach higher. As the American League did in 1901–1902, the Federal League announced it was a *major* league and began raiding the two established leagues of their star players. The upstart group went head-to-head with the big leagues in four of their eight cities, and one was St. Louis.

One city, three teams. It was a fan's dream, a ballplayer's wish, and an owner's nightmare. Eighty-one major leaguers jumped to the Federal League, and salaries in all three leagues rose dramatically. Players, who had been tied to one team with the "reserve clause," now had a choice; this gave them leverage. Some were "double-jumpers," who returned to their original teams when lucrative salaries were matched. A flurry of lawsuits and counter-suits followed this player movement. Attendance in the established leagues plummeted, and losses mounted in all three leagues.

For Miller Huggins, the new manager of the Cardinals, it was baptism by fire. First, he took over amid a swirl of controversy since the popular (especially with the press) Bresnahan was unceremoniously dumped by Lady Bee. Now Huggins faced a loss of players, including two-thirds of his promising outfield (Steve Evans and "Rebel" Oakes) to the rival league. A year later he lost his third outfielder, Lee Magee, to the Feds too. In 1913, the Cardinals were wracked by dissension (pro-Bresnahan and pro-Huggins factions), exacerbated by an even worse record than in 1912. There were constant rumors and reports that the rookie skipper wouldn't last the season.

He did; the Brittons decided to give him a chance. That winter, Huggins put his stamp on the team. He sent the city's biggest and most unhappy star, Ed Konetchy, to Pittsburgh in a blockbuster multi-player deal. The trade was initially termed a disaster for the Cardinals. Instead it blossomed into a great move for them, one that enabled the team to make a spirited run for the pennant in 1914.

The Federal League's St. Louis Terriers installed famous Chicago Cubs' pitcher Mordecai Brown as their manager in 1914. (Former Cardinal manager Jack O'Connor had headed the team when it was in a minor league in 1913). Brown's easygoing personality wasn't a good fit in the eyes of owner Phil Ball and, before the season was out, he brought Fielder Jones out of retirement to lead the team. The skipper of the 1906 world champion Chicago White Sox had been out of baseball for more than five years, yet his reputation as a savvy winner earned both him and the Terriers instant respect. In 1915, Jones led them to the closest second-place finish in baseball history, .001 behind the Chicago Whales. His line-up that wasn't much different from the last place finisher of the year before.

Things were not static with the Browns. Their manager, George Stovall, was fired after splattering an umpire with spit and tobacco juice late in the 1913 season. His hiring by the

Federal League's Kansas City Packers, while he was still playing first base for the Browns, was one of the first shots across the bow.

Earlier that season, Browns' owner Bob Hedges had hired a former Brown catcher named Branch Rickey as his scout and executive. As manager of the University of Michigan baseball team, Rickey had developed a network of contacts, and his intelligence and astuteness had impressed Hedges years earlier. Soon after Stovall was let go, Rickey became the Browns' new manager.

During these years, baseball was being played elsewhere in St. Louis and at other levels. Black baseball players, who were unable to play in organized ball due to their race, had their own teams, which were loosely confederated. Charley Mills' St. Louis Giants were the main team.

The 'teens were also the peak of the popularity of sandlot, or semi-pro, ball throughout the Midwest. St. Louis' Trolley League had the highest level of competition in the area, and many future major leaguers had their start here. One semi-pro team was the most famous for producing big-league ballplayers: John Sheridan's Wabadas.

Almost lost beneath the din of the league wars was the arrival of two young ballplayers in St. Louis: an unheralded infielder named Rogers Hornsby and a touted college pitcher by the name of George Sisler. Cardinal scout Bob Connery signed the former for $500, and Branch Rickey ushered his Michigan star to the Browns. They would dominate baseball for more than a decade and are still today considered two of the greatest hitters the game has ever known.

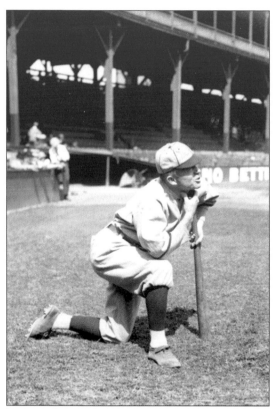

MILLER HUGGINS.

His record [as St. Louis manager], *considering that he had little money at his disposal, has been remarkable.*
–John E. Wray, *St. Louis Post-Dispatch*, October 26, 1917

In 1913 he took over as the Cardinals' manager. Faced with player desertions to both the Federal League and the New York Giants, and constrained by his team's limited payroll, he twice brought them to third place. That was higher than the Cardinals had finished in that century.

Huggins had a strong grasp of the intricacies of the game, and he was a patient teacher. He had no choice but to develop young players like Doak, Hornsby, and Perritt, since he lacked the money to buy established stars. He would return to this approach in the mid-1920s, when he had to rebuild the Yankees, and other teams wouldn't trade with him. Like Branch Rickey, Huggins also was a remarkable judge of talent. Once Rickey became the Cards' president in 1917, especially after Huggins had lost out on a chance to buy the team from Mrs. Britton, it was time for Huggins to move on. The man whom *The Sporting News* had dubbed "Little Miracle Worker of the West" went to the American League to manage the Yankees. He would win six pennants and three world championships there. He was elected to the Baseball Hall of Fame in 1964. (Courtesy of the Chicago Historical Society.)

52

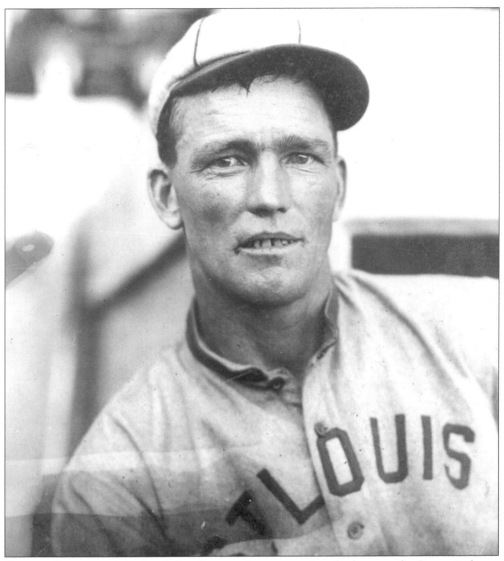

GEORGE STOVALL. A hotheaded and pugnacious competitor, he became the Browns' player-manager in 1912 and was fired (as manager) amid controversy a year later. He became the first major leaguer to sign with the rebel Federal League, as the manager of the Kansas City Packers. Stovall then angered Bob Hedges and Branch Rickey by using his connections with the Browns to recruit for the new league. "Firebrand," as he was called, never returned to the majors after the demise of the Federal League in 1915. He briefly came back in the news almost 50 years after his death, in 1996, when Roberto Alomar spat in the face of umpire John Hirschbeck. The 1913 incident that led to Stovall's firing as Browns' manager was his spitting tobacco juice into the face of umpire Charlie Ferguson. As Brown third baseman Jimmy Austin told author Larry Ritter more than a half century later, in *The Glory of their Times*: "George spit himself out of a job . . . George let fly with a big gob of tobacco juice—p-tooey!—that just splattered all over Ferguson's face and coat and everywhere else. Ugh, it was an awful mess."

A solid-fielding first baseman for the Cleveland Indians for a number of years, Stovall was known for his dramatic and difficult fielding play, with two outs in the ninth inning, which preserved Addie Joss' Perfect Game in 1908. (Courtesy of the SABR-Ottoson Photo Archive.)

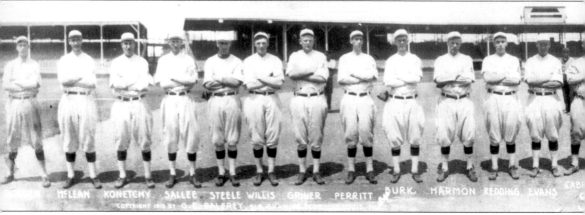

MCLEAN KONETCHY SALLEE STEELE WILLIS GRINER PERRITT BURK HARMON REDDING EVANS CAB
COPYRIGHT 1913 BY G. F. BALFREY. SAN ANTONIO.

1913 St. Louis Cardinals. This was Miller Huggins' first year as manager. He is just to the right of the team's mascot, owner Helene Britton's little boy. Two players of interest on the team are Larry McLean and Lee Magee. Sportswriter Sid Mercer described McLean (second from left) as "a child of trouble and football of fate." McLean wrestled with his chronic drinking for years and was involved in many barroom brawls, though he was a gentle man when sober. His Chicago Cubs' manager Hank O'Day was once asked who would start at catcher that day. "The big fellow [McLean was 6' 5"], if he can see 'em." His major league career ended in the bar of St. Louis' Buckingham hotel, in a drunken encounter with his manager John McGraw and scout Dick Kinsella. When the New York Giants signed McLean during the 1913 season (the Cards had traded him for Doc Crandall), they put a "good behavior" clause into his contract. Kinsella had just informed McGraw that the big catcher had been drinking. When McLean heard the news,

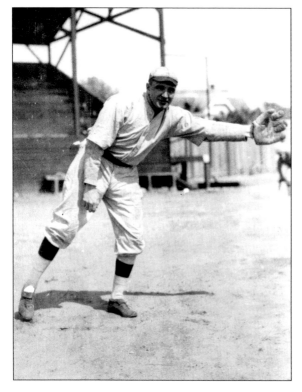

Al "Cozy" Dolan. A utility infielder for most of his career, he was a regular outfielder for the Cardinals in 1914 and 1915. He came to the Cardinals in the Konetchy-Miller trade with Pittsburgh. His .280 season in 1915 was his last, other than a pinch-running appearance as a Giants' coach in 1922. In 1924, still coaching for New York, he was alleged to have approached one of his players (Jimmy O'Connell) to "fix" games with Philadelphia. In the Commissioner's investigation, Dolan said he couldn't remember the events of just a few days earlier. Judge Landis banned Dolan and O'Connell for life. The entire controversy remains unclear. Did Dolan hatch the plan on his own? If not, who suggested it to him? (Library of Congress, Prints and Photographs Division.)

which would cost him $1,000 of his pay, he smashed a chair over Kinsella and was soon released by McGraw. Less than six years later, a bartender shot and killed McLean during a fracas.

Magee (third to the right of mascot Britton, with hands on his waist) was once called "the coming Ty Cobb of the National League," yet he never reached that promise. Born with one of the longest names in baseball history, Leopold Christopher Hoernschemeyer was a starting outfielder for the 1912–1914 Cardinals, for whom he hit .280. He jumped to the Brooklyn Tip-Tops of the Federal League in 1915 and became the youngest manager (player-manager) in the game at the age of 25. He hit .323 that year and then played for five different teams in the next four years. He confessed to betting against his own team and was soon banned from the game by Commissioner Landis. (Courtesy of the St. Louis Cardinals Hall of Fame Museum.)

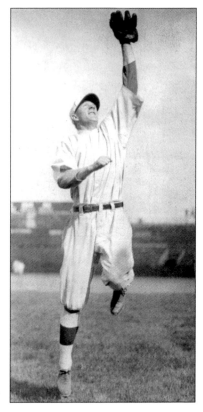

ZINN BECK. A utility infielder for the Cardinals from 1913 to 1916, Beck went on to a 70-year career in professional baseball. A career .226 hitter in the bigs, he jokingly told people that he learned to hit only after he left the big leagues. As player-manager for Columbia and Greenville in the Sally League in the early 1920s, he had some terrific hitting seasons, including a league-leading .370 in 1923. Beck later went on to a 50-year scouting career, primarily for the Griffith family and its Washington-Minnesota teams. (Courtesy of *The Sporting News*.)

FRANK "PANCHO" SNYDER. He joined the Cardinals as a teenager in 1912 and took the starting job away from Ivey Wingo two years later because of his defense and quickness. Born in San Antonio, he was called "Pancho" because of his Spanish heritage. In one of Branch Rickey's rare trading errors, the Cards sent him to New York for pitcher Ferdie Schupp, who had only one more good year, 16 wins in 1920. Snyder became the starting catcher for four straight pennant winners in New York, where he played at least 100 games each year. Surprisingly, he hit over .300 three of those seasons. He returned to the Cards in 1927 and later was a New York Giants' coach for many years. His 204 assists in 1915 ranks as one of the top single-season marks for a catcher. (Courtesy of the Library of Congress, Prints and Photographs Division.)

IVEY WINGO. He was a member of the Cardinals from 1911 to 1914, and their regular catcher in 1912 and 1913. He then went on to a long career with the Cincinnati Reds, including catching in the 1919 World Series against the Chicago Black Sox. Wingo was known more for his bat than his glove. He hit over .260 nine times, and he led the National League in errors by a catcher seven times. He also owns the modern era record for career errors by a catcher with 234. He still ranks high in all-time assists and assists per game. (Courtesy of the Private Collection of Dennis Goldstein.)

In the 'teens, the Cardinals had a remarkable trio of catchers who had similar career numbers for batting average, on-base percentage, and slugging average.

Name	Career BA	OBP	SLG
Frank Snyder	.265	.313	.360
Ivey Wingo	.260	.307	.355
Mike Gonzalez	.253	.314	.324

ED KONETCHY. Increasingly unhappy in St. Louis in 1913, he was the focus of the anti-Huggins faction on the team, and then became the centerpiece of Huggins' big trade with Pittsburgh that winter. This photo shows Konetchy in the hills of Hot Springs, Arkansas, for spring training 1914. He's wearing his old Cardinal sweater and his new Pirate hat. While Koney and the Pirates started 1914 strongly, they both faded badly. He hit only .249, his worst since 1908, and the team finished in seventh place. Still, a couple of things didn't change: he played in all 154 games, and he led the league's first basemen in fielding percentage, one of eight times he did so. The following year, he jumped to the Pittsburgh Rebels of the Federal League. He later spent three seasons with the Boston Braves and three with Brooklyn, including the 1920 pennant winners. (Courtesy of the Library of Congress, Prints and Photographs Division.)

HANK ROBINSON. After a combined 26-16 record for the 1912–1913 Pittsburgh Pirates, he came to St. Louis in the Konetchy-Miller trade. Robinson went only 14-16 for the Cardinals the next two years and then won only two more games in the bigs. Miller Huggins did not forget Robinson when he took over the Yankees, and the pitcher got one last chance in the majors, in New York in 1918. Like many players of his day, he went on to a long minor-league career *after* his stint in the majors was done. Unlike most players, his minor league career was spectacular: he won more than 200 games, including four 20-win seasons. "Rube," nicknamed for hailing from the small town of Floyd, Arkansas, played for Little Rock for more than a decade. His career mark in the majors was 42-37, yet he won more than 300 games overall (minors and majors). He is seen here at the Cardinals' 1914 spring training site in St. Petersburg, Florida, still wearing his Pittsburgh jersey, just as Ed Konetchy (who went *to* Pittsburgh in the same trade) was still wearing his Cardinal sweater in the Pirates' spring training camp. (Courtesy of Culver Pictures.)

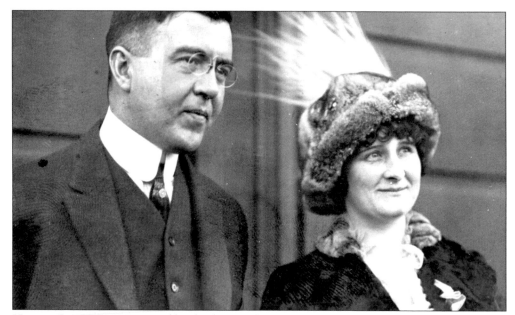

HELENE BRITTON. Britton and her husband Schuyler (seen here), who served as team president for a period of time, stood by their new manager Miller Huggins during the difficult 1913 season, when rumors and even suggestions of his demise were often heard. At the end of that year, she let Huggins trade away the team's biggest star, Ed Konetchy. The deal was criticized at the time but benefited the Cardinals in the long run. Though the Cardinals finished in third place in 1914, the competition with another team in town (the Federal League's Terriers) depressed attendance, which was barely more than half of the 1911 numbers. Financial pressures increased in the next two years, and the demise of the Federal League was offset by the team's fade to last place in 1916. When her marriage fell apart later that year, Lady Bee put the Cardinals up for sale. She sold the team to a group of local investors early in 1917. (Courtesy of Culver Pictures.)

BOB BESCHER. A strong leadoff hitter, he led the National League in stolen bases from 1909 to 1912, while with Cincinnati. His 81 steals in 1911 stood as the modern NL record until Maury Wills broke it in 1962. Surprisingly quick for so large a ballplayer (6'1", 200 lbs), he had a temper and tangled even with managers, including his own, John McGraw. He once punched Cardinals' manager Roger Bresnahan, and when the Reds next played in St. Louis, dozens of policemen had to patrol the outfield between Bescher and the fans. Bescher spent 1915–1917 in St. Louis, where his performance really dropped off, as his batting average fell to .263, .235, and .155 those three years. (Courtesy of the Mercantile Library/UMSL.)

MORDECAI "MINER" BROWN. In 1914, he returned to St. Louis, to manage and pitch for the Federal League's Terriers. Most of the upstart league's teams had a few name players and many high-level minor leaguers. The Terriers had but one established star: Mordecai Brown. With the team floundering in seventh place in late August, owner Phil Ball felt he needed a firmer hand and more experienced skipper at the helm. He replaced Brown with Fielder Jones, the retired manager of the Chicago White Sox. Brown had one more good season left in his arm: a record of 17-8 with a 2.09 earned run average for the Feds' Chicago Whales in 1915. That team edged out Fielder Jones' Terriers in a thrilling pennant race.

While he is now often referred to as "Three-Finger" Brown (for a farming accident as a youth that cost him two fingers), he was often called "Miner" Brown during his career, a reference to his Indiana coal-mining background. Brown later pitched and managed in the minors for a few years, ending his playing career in 1920 where he started in 1901, in Terre Haute, Indiana. He was elected to the Baseball Hall of Fame in 1949. (Courtesy of the Library of Congress, Prints and Photographs Division.)

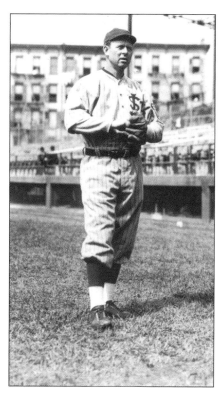

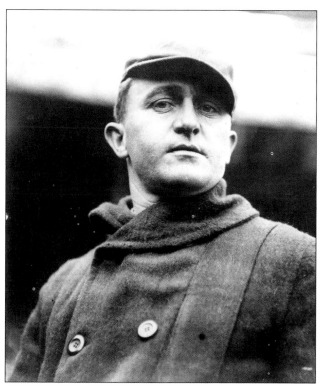

"HUB" PERDUE. Less than a year after winning 16 games for the 1913 Boston Braves, he was traded to the Cardinals and missed out on the comeback of the 1914 "Miracle Braves." Perdue won only 14 more games in the bigs, for the 1914–1915 Cardinals. Sportswriter Grantland Rice gave him one of the game's most colorful nicknames, "The Gallatin Squash." He hailed from Gallatin, Tennessee, and his squat shape reminded some of the Hubbard squash. He is seen here just before the 1914 trade, wearing his Braves' jacket. (Courtesy of the Library of Congress, Prints and Photographs Division.)

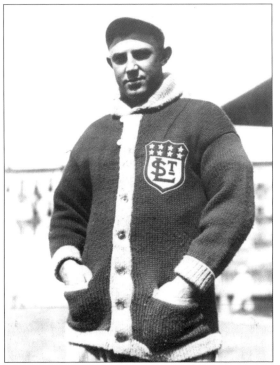

JAMES "DOC" CRANDALL. One of the first pitchers used regularly as a reliever, he had a record of 45-16 for the 1910–1912 Giants, and most of his appearances were in relief. Crandall also sparkled in relief in the 1911, 1912, and 1913 World Series, with a 1.69 earned run average. Damon Runyon gave him the nickname "Doc" for being "the first to aid the injured . . . the physician of the pitching emergency." In 1914 he came to St. Louis, joining the Terriers, where he won 34 games in 1914–1915. Known as one of the game's best-hitting pitchers, he had a career .286 batting average. Crandall then went on to a decade-long stint in the Pacific Coast League, where he won at least 15 games each year, with five 20-win seasons. (Courtesy of the Library of Congress, Prints and Photographs Division.)

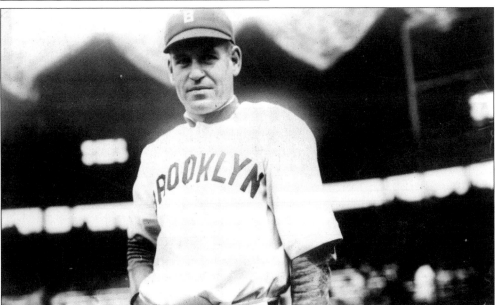

STEVE EVANS. Federal League executives met the World Tour boat, the *Lusitania,* when it docked in New York, and they quickly signed Evans. He flaunted his jump to the Federal League and the money he got from Brooklyn. He was seen in New York City that very night, showing off $1,000 bills. While there was no formal blacklist after the league folded, Evans was probably the best player who did *not* get an offer back in the bigs and never played another game, after hitting .308 in 1915 at age 30. (Courtesy of the Library of Congress, Prints and Photographs Division.)

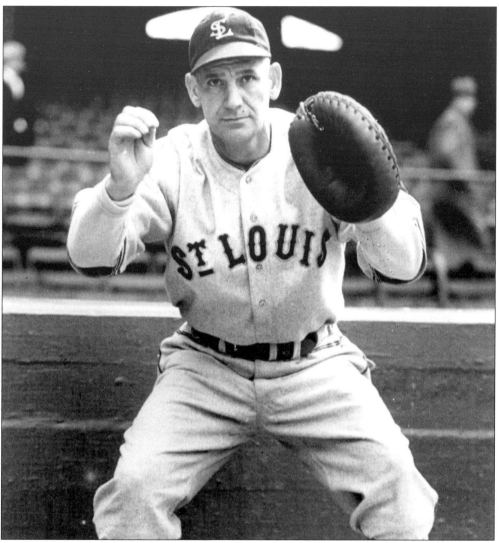

GROVER HARTLEY. He spent four years in St. Louis in the first quarter of the century: 1914–1915 with the Terriers and 1916–1917 with the Browns. A journeyman catcher who appeared in 100 games in only two seasons, Hartley stayed in the bigs because of his skills behind the plate. "Slick" had a reputation for shrewdness and calling an intelligent game. One pitcher in particular liked to work with him: Doc Crandall. The two men crossed paths a few times in their careers. They were teammates on the great New York Giant teams of 1911 to 1913. Hartley and Crandall offered their services to the St. Louis Terriers as a tandem. In 1914, the Terriers agreed to sign them both and release them only as a pair, together, or not at all. They helped the Terriers come within .001 of the 1915 Federal League pennant—Hartley caught 113 games and hit .274, and Crandall won 21 games.

After a couple of marginal seasons with the Browns, Hartley went to Columbus for six years, where he hit over .330 three times. In the early 1930s, he and Crandall reunited yet again, as Pittsburgh Pirate coaches. Hartley returned to St. Louis to coach for Rogers Hornsby and the Browns from 1934 to 1936. In '34 he appeared in five games in his mid-40s. He had a 14-year big-league career, though he played in only 569 games, an average of 41 a year. (Courtesy of the National Baseball Hall of Fame Library, Cooperstown, New York.)

"Spitting" Bill Doak. He had a stunning rookie season for the Cardinals in 1914 and was a key contributor to the team's surprise third-place finish that year. Doak had a 19-6 mark, with seven shutouts, and led the league with a 1.72 earned run average. He went on to have three comebacks in his 16-year career, most of it with the Cards. In the early 1920s, Doak pitched three one-hitters. In all three games, the lone hit was an infield roller that he could have handled for an out, had he gotten off the mound more quickly. He still ranks second on the team's career shutout list, behind Bob Gibson.

Doak was a quiet and serious man, and a very slow worker on the mound. He was a slender spitball pitcher who had back problems and was called "Lumbago Bill" in the papers. Yet he was durable enough to win both ends of a double-header in 1917 (both complete games). After three straight losing seasons with the Cardinals, Doak bounced back with a combined 35-18 record in 1920–1921. After a couple of mediocre seasons, the Cardinals traded him to Brooklyn, where he won 10 straight games late in the 1924 season and brought the Robins to the verge of the NL pennant. Doak's final comeback was in 1927, when he returned to Brooklyn after a two-year absence from baseball to sell real estate in Florida. At the age of 36, he won 11 games.

Doak is most remembered for the glove that bears his name. In 1919, he approached the Rawlings Sporting Goods Company of St. Louis, to design an improved glove. Ironically, the revolutionary glove, a dramatic improvement over earlier models, appeared in the first year of the Lively Ball Era, 1920. It was designed with a natural pocket and webbing laced between the thumb and first finger. The Bill Doak glove was sold for decades and provided the former pitcher a steady stream of royalties during his retirement. (Courtesy of the Library of Congress, Prints and Photographs Division.)

JOHN "DOC" LAVAN. He had a tough start in the bigs in 1913, hitting only .141, with 46 strikeouts in just 149 at bats for the Browns. When Jack Barry of the Athletics went down with an injury late that year, the Browns "lent" him to Philadelphia for the remainder of the season, where he hit only .071. Still, with a generosity that was common of the Athletics in that era, he was voted a full winners' World Series share. That money enabled him to finish medical school at the University of Michigan, where he played baseball for Branch Rickey. "Doc" served as a Medical Lieutenant during World War I and was the commander of the Brooklyn Naval Hospital in World War II. (Courtesy of the National Baseball Hall of Fame Library, Cooperstown, New York.)

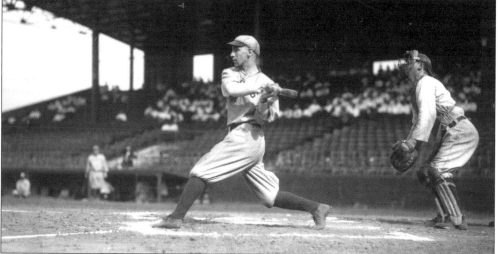

DOC IN ACTION. He spent the first few years of his career with the Browns and the last few with the Cardinals. A career .245 hitter who led his league in errors four times, he covered a lot of ground and had the reputation as a slick fielder. In September 1917, when Phil Ball accused his players of "laying down," Lavan and teammate Del Pratt took offense and sued for slander, even though Ball had mentioned neither man and had given no names. Lavan was soon traded to Washington, along with another Brown, Burt Shotton. While the issues behind Ball's charges remain murky and complex, Branch Rickey thought highly enough of both Lavan and Shotton that he picked them up for the Cardinals in early 1919. (Courtesy of the Walter P. Reuther Library, Wayne State University.)

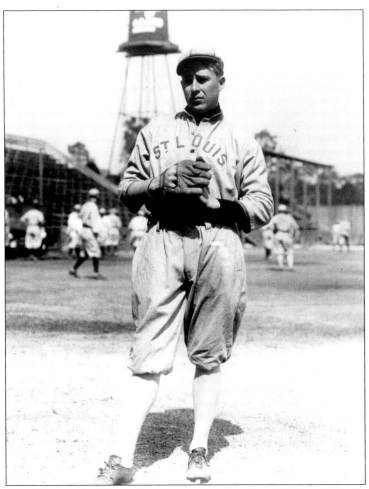

EARL HAMILTON. He was the Browns' winningest pitcher from 1912 to 1914, including a no-hitter against the Tigers in 1912. When the Federal League began raiding the established leagues, Hamilton became a central figure in one of the early battles. His former Browns' manager of 1912–1913, George Stovall, signed him for the Kansas City Packers, the team Stovall would manage in 1914. Earl Hamilton probably spoke for many ballplayers, who appreciated the choice the Federal League presented, when he said, "I'm tired of playing for glory. It is a question of money." American League president Ban Johnson, who designed the raids on the National League 12 years earlier, responded, "The American League will stop Hamilton if it takes every dollar in the treasury."

Ultimately and quietly, Earl Hamilton returned to the Browns, without ever playing a game for the Packers; Bob Hedges probably upped the ante and matched the KC offer. The Federal League sued, but this move was not successful. After all, Hamilton was under contract to the Browns at the time. Unlike many players who were simply tied to their teams by the reserve clause, Hamilton was in the midst of a three-year contract.

He worked 302 innings for the Browns that year. A couple of years later, when the team had the pickings from the now-defunct Terriers, as well as their own club, the Browns waived Hamilton to the Detroit Tigers. He didn't stick with them, and less than a month later, St. Louis re-claimed him. He had a 0-9 record for the 1917 Browns, who sold him to Pittsburgh. He went 6-0 in 1918 and rejuvenated his career. He went on to win 55 games after 1917. (Courtesy of the Library of Congress, Prints and Photographs Division.)

BURT SHOTTON. A leadoff speedster for Branch Rickey's Browns, he later played for Rickey's Cardinals and managed for Rickey's Brooklyn Dodgers in the 1940s. Between 1912 and 1916, Shotton had an on-base percentage of around .400 four times with the Browns. He led the AL in walks twice and stole 40 or more bases four straight seasons, from 1913 to 1916. Shotton also had tremendous range in the outfield. He earned the nickname "Barney" for his speed, like racecar driver Barney Oldfield. Shotton was hampered by injuries in 1917—his .224 batting average that year was far below his norm. He was said to have been one of the players owner Phil Ball had in mind when he charged his players with "laying down" that September. When Ball traded Johnny Lavan to Washington later that year, Shotton was included in the deal. (Courtesy of Michael Mumby.)

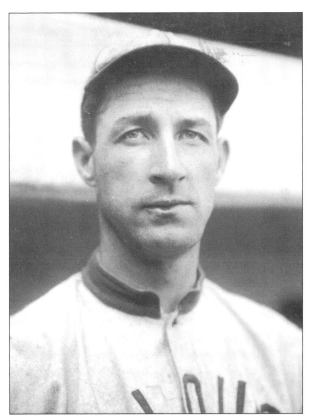

ALPEN BRAUS. They were one of the best teams in the Trolley League during the 'teens. This photograph is *circa* 1915. Semi-pro, or sandlot, ball was immensely popular in St. Louis at the time, both playing and watching the games. (Courtesy of Oscar Schneider/Missouri Historical Society, St. Louis.)

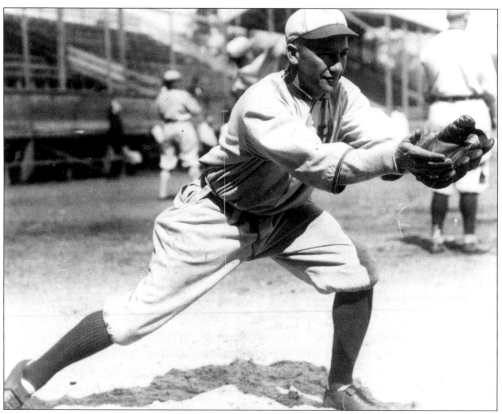

DEL PRATT

He was the greatest clubhouse lawyer baseball ever knew.
—John Kieran, "Sports of the Times," *New York Times*, June 17, 1929

Fielder Jones called him one of the best natural hitters he'd ever seen (*Baseball Magazine*, April 1918). Pratt, a fine all-round player, was one of the league's best-fielding second basemen and a consistent hitter who rarely missed a game. He broke into the bigs in 1912 with a fine rookie season for the Browns and gave them five solid years. From 1912 to 1916, he hit between .267 and .302 and averaged 156 games, 31 steals, and 31 doubles a year. He then had a difficult 1917 that ended in a lawsuit and a trade.

He is one of the few baseball players who hit .300 in his first and last full seasons. A line-drive hitter, 28 percent of his hits were for extra bases. In 1916, he led the league in runs batted in with 103. He ranked high in many defensive categories, with only Eddie Collins playing at his level. Pratt led the league in chances and putouts five times each, and double plays and assists three times each. He had remarkable range until his last two seasons, when he slowed down dramatically.

He broke his wrist early in 1917, and it hampered his play all year—a .247 season with only 53 runs batted in. When owner Phil Ball accused his players of "laying down" in early September, Pratt and teammate Johnny Lavan sued for slander. The lawsuit was Pratt's ticket out of town; he was traded to the Yankees that winter, in Miller Huggins' first deal as New York's skipper. Pratt had three solid years as a Yankee. He then spent two seasons each in Boston and Detroit, hitting above .300 all four seasons. He went on to manage and play in the Texas League, where, in 1927, at age 39, Pratt hit .386 with 32 home runs and 140 runs batted in for Waco. (Courtesy of the Library of Congress, Prints and Photographs Division.)

PRATT IN ACTION. Pratt was known for his toughness and stubbornness. He triggered a brawl in a 1913 City Series game against the Cardinals. He didn't turn the other cheek when Phil Ball made his charges in 1917. In New York, he led a dispute over how third-place money was divided, and in 1920, he was a focal point of the anti-Huggins faction on the Yankees. Before the Yankees traded him that winter, he almost took the baseball coaching job at the University of Michigan, with the help of Branch Rickey's recommendation. Ultimately another ex-Yankee filled that position—brilliantly, for almost forty years—Ray Fisher. Pratt is seen here in action early in his career. (Courtesy of Michael Mumby.)

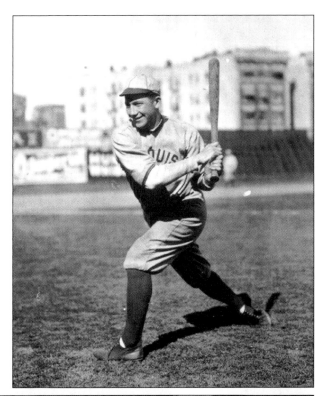

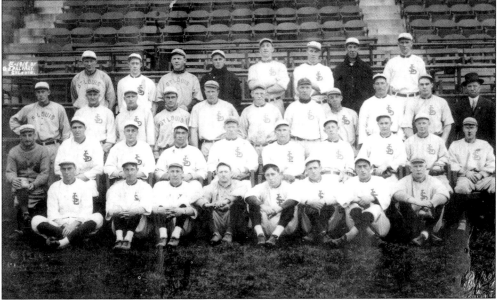

1914 ST. LOUIS BROWNS. This was the first full season as a manager for Branch Rickey (second row, third from left). In the front row are five men who were key figures in St. Louis baseball, discussed elsewhere in this book. They are, from left to right, star-crossed pitcher Carl Weilman, coach Rickey's right-hand man; Burt Shotton; sensational young infielder Del Pratt; long-time Browns' player and coach Jimmy Austin; and Earl Hamilton, focus of legal battles with the Federal League. (Courtesy of Michael Mumby.)

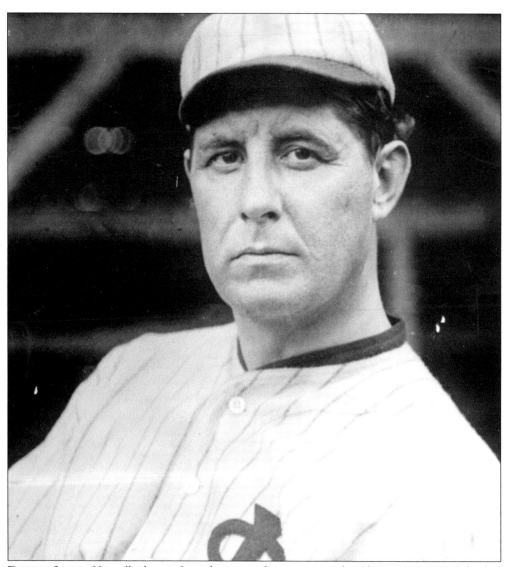

FIELDER JONES. He walked away from the game after managing the Chicago White Sox for five years, including a world championship in 1906. Jones was lured away from his Pacific Northwest lumber business late in the 1914 season by a lucrative contract, to manage the St. Louis Terriers. He led them to an 87-67 record in 1915, about as close to first place (and Chicago's 86-66) as was possible. Hopes ran high for the Browns, when Terriers' owner Phil Ball bought the AL team and gave Jones the personnel of the two clubs to work with. But a seventh place finish in 1916 was followed by a mediocre start, and, after a particularly difficult loss in 1917, Jones suddenly left baseball again, never to return. In February 1917, *Baseball Magazine* described Jones as "cool, calm, calculating, mercilessly sarcastic." A stern taskmaster and brilliant tactician, he rarely (never?) smiled and often fought with umpires. A fight during the 1915 season with Federal League umpire Harry Howell triggered Jones' threat to resign over poor officiating. The actual issue was more complex—league officials wanted owners to ante up money based on stock ownership. Jones owned stock—it was given to him when he joined the team—and he didn't want to pay up. As amazing as it may seem, the name Fielder was give to him at birth. (Courtesy of the National Baseball Hall of Fame Library, Cooperstown, New York.)

CLARENCE "TILLY" WALKER. He was a Browns' outfielder from 1913 to 1915, hitting a solid .294, .298, and .269. Yet it was in the field that Walker made his mark: he had terrific range and a strong, accurate arm. He led the league in outfielder assists three times. He was then sold to the Boston Red Sox. Browns' manager Fielder Jones made the move because he felt Walker was more concerned with his own numbers than the team's performance. He also didn't like Walker's attitude; "quite a hitter when he feels like hitting" was the way one writer put it. Walker spent the last six years of his career with the Athletics. He tied for the American League lead in home runs in 1918 (with Babe Ruth), and then he hit 23 homers in 1921 and 37 in 1922. (Courtesy of Brace Photo.)

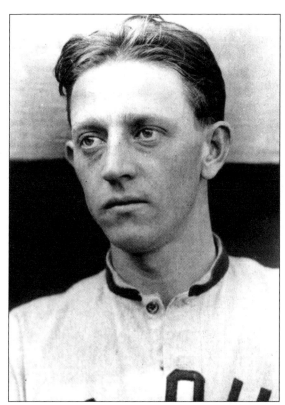

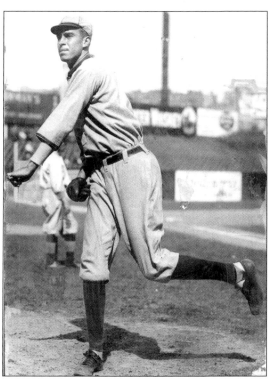

CARL WEILMAN. During an eight-year career with the Browns, he fought kidney illness, ultimately losing his battle. He lost one kidney and had to retire for the 1918 season. Weilman made a stirring comeback in 1919, with his 10-6 record and an earned run average just above 2.00. But 1920 was not nearly so good: 9-13, with an earned run average of almost 4.50. When his other kidney got infected and caused health problems, Weilman retired. Known as "Zeke" for his big physique (6' 5^1/$_2$"), he also had a big heart. Ultimately that courage was not enough, as he succumbed to kidney-related problems in 1924 at the age of 34. (Courtesy of Michael Mumby.)

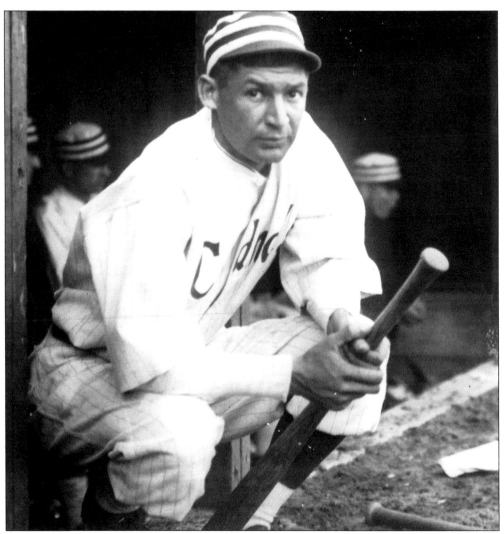

JOHN "DOTS" MILLER. Sometimes there comes along a player who doesn't seek the limelight and quietly does so many positive things—both on the field and in the clubhouse—that his worth is often much greater than it appears to be. Jack Miller came up as a 22-year-old with Pittsburgh and immediately became Honus Wagner's double-play partner in 1909. He hit .279 that year and helped the Pirates win the pennant and the World Series. When Miller Huggins sent Ed Konetchy to the Pirates in a blockbuster multi-player trade in the winter of 1913-1914, most people thought the Cardinals' manager had been duped. Less than a year later, it was almost unanimous that "Hug" had come out on top, and the reason was Dots Miller. He hit .290 in 1914 and became the informal field general. Years later, Rogers Hornsby credited Miller with helping him find his style by cheerfully spending time with the young recruit. Miller seemed destined for success as a big league manager. In his first year at the helm of a club, he led the San Francisco Seals to the 1922 pennant. Less than a year later, he died of tuberculosis in Saranac Lake, New York, just before his 37th birthday. Renowned sportswriter Charlie Dryden paid Miller a compliment when he once wrote that the ideal team would have nine Jack Millers, one at each position. One of the explanations of his nickname is that, when Miller first came up to the Pirates, reporters asked Honus Wagner whom the new kid was. Wagner replied in his heavy German accent, "Dot's Miller." (Courtesy of the Mercantile Library/UMSL.)

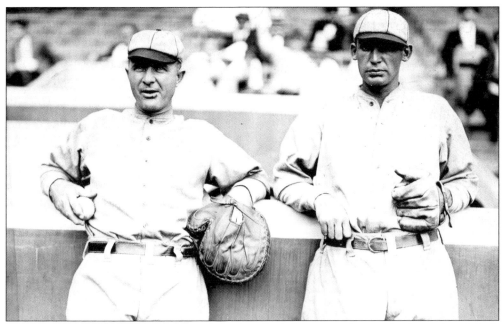

PATRICK "PADDY" O'CONNOR. Seen here (on the left, wearing his catcher's mitt) with Jack Miller, the Irish-born Paddy O'Connor was hired by Miller Huggins as a Cardinals' coach in 1914. He also appeared in 10 games. The following year he jumped to the PittFeds, where he had most of his career at bats in that one year. Miller Huggins didn't hold the move against O'Connor and hired him to coach the Yankees for a few years starting in 1918. O'Connor was Lou Gehrig's manager in Hartford in 1923, and Gehrig credited O'Connor with helping his development. (Courtesy of Culver Pictures.)

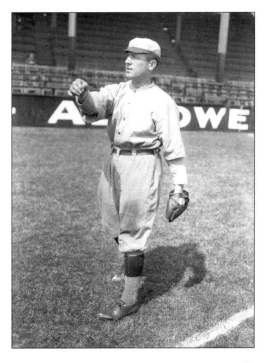

CHARLEY O'LEARY. With shortstop Arnold Hauser out indefinitely, Huggins turned to the veteran O'Leary to step in. He had been the starting shortstop for the Detroit Tigers for a few years. Starting in 1908, he had been a reserve, and he played for Jimmy Burke in Indianapolis. O'Leary gave the Cardinals 121 games in 1913; he hit only .217, which was actually quite close to his career batting average of .226. O'Leary hooked up with Huggins again in 1920, when he joined the Yankees as a coach and held that role for 11 years. Jimmy Burke took his place there in 1931. O'Leary returned to St. Louis in 1934, as a coach for Rogers Hornsby's Browns. Now 51 years old, and 21 years after his last at bat, O'Leary came to the plate once that season and got a hit. When he came around to score, he became the oldest person in baseball history to do so. (Courtesy of the Chicago Historical Society.)

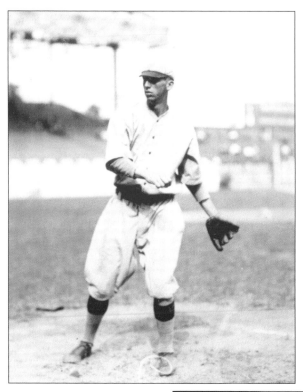

POL PERRITT. He and Slim Sallee were tall, angular hurlers who teamed with Bill Doak for 53 wins for the 1914 Cardinals. Miller Huggins was counting on "Pollie," as he called one his favorite players. Instead, when 1915 rolled around, Perritt was a member of John McGraw's Giants. While the upstart Federal League hurt most teams, McGraw used it to his advantage. When McGraw heard that a player he liked was about to jump to the "Feds," he offered to bring the player to New York, where the salaries were higher and the likelihood of World Series money was greater. Perritt's success with the Giants (65 wins, 1915–1918) was an extension of his 1914 season with the Cardinals, one in which Huggins worked a lot with him. (Courtesy of the Private Collection of Dennis Goldstein.)

SLIM SALLEE. In 1913, he won 19 of his team's 51 victories. Sallee continued as the team's workhorse, with more than 275 innings pitched four straight years (1912–1915). When Miller Huggins took over the team in 1913, the problems of Slim's "violating training rules" (a euphemism for drinking problems) did not go away. The friction between the fun-loving player and straight-laced manager increased, until Slim felt he could no longer stay with the Cardinals. He was dealt to the New York Giants the following season. (Courtesy of William Trefts/Missouri Historical Society, St. Louis.)

FOUR

Change at the Top

1916–1919

After two years of battles and financial losses, organized ball returned to the two established leagues in 1916. The Federal League made peace with (some said, "surrendered to") organized ball. Unlike the AL-NL settlement 13 years earlier, the new league did not attain equal status. Instead, it disbanded for a price and was able to sell its players back to the established leagues. The Baltimore Federal League team owners refused to settle and went forward with an antitrust lawsuit against major league baseball before a judge who would later become the Commissioner of baseball, Kenesaw Mountain Landis. Ultimately, the Baltimore team would not prevail.

The settlement set in motion some profound changes in St. Louis baseball. First, Terriers' owner Phil Ball bought the Browns from Bob Hedges for $425,000. Hedges had grown weary of the losing—both games and money— and the impending lawsuit only added to his worries. (One other Federal League owner, Charles Weeghman, bought an established team, the Chicago Cubs. Hallowed Wrigley Field was the former ballpark of the Chicago Whales, Weeghman Park.)

The Browns got not only a new owner but also practically the entire Terrier team and their manager Fielder Jones. Branch Rickey gave up that post and focused on the team's administrative and personnel matters as business manager. Jones suddenly resigned during the 1918 season and was replaced by a former Cardinal player and manager, Jimmy Burke.

Early in 1917, Helene Britton also decided to sell for some of the same reasons as Bob Hedges, as well as due to the breakup of her marriage. Cardinals' attorney James C. Jones put together a local group of public investors that bought the team for $375,000. They raised the money by selling shares of stock in the team. The team offered its presidency to Branch Rickey of the Browns. The timing was good since Rickey and Phil Ball were not working well together.

The year 1917 was a mixed bag for Miller Huggins and the Cardinals. For the second time in four years, they finished a surprising third in the pennant race. But Huggins was disappointed that his own group of investors was unable to buy the Cardinals, and the arrival of Branch Rickey had curtailed Huggins' authority in matters of player personnel. At the same time, American League president Ban Johnson was upset over his league's loss of a bright young executive (Rickey) to the National League. With the help of the owner and editor of St. Louis' *The Sporting News*, Johnson encouraged the contacts that led to Huggins' hire as manager of the American League's Yankees.

Rickey's departure was a loss for the Browns, but Phil Ball quickly hired a capable successor in Bob Quinn, who for many years had run the Columbus, Ohio minor league franchise. He began assembling the players of what would arguably be the greatest Browns' group ever, the 1922 team. His first major deal was with the new manager of the Yankees, Miller Huggins, before the 1918 season. Quinn acquired young pitcher Urban Shocker and four other Yankees in exchange for the Browns' disgruntled star second baseman Del Pratt and aging pitcher Eddie Plank.

The changes did not work out as well for the Cardinals. They hired a successful minor league manager, Jack Hendricks, to replace Huggins, but the team won less than 40 percent of its games. Was this due to the absence of Huggins or to the maddening St. Louis tendency of following up a good and promising season (the Browns 1902 and 1908; the Cardinals 1914 and 1917) with a disappointing and bad one? Whatever the reason, the Cardinals were heading in the wrong direction.

George Sisler and Rogers Hornsby were emerging superstars in the late 'teens. In a Deadball Era dominated by pitching, they put up impressive hitting numbers:

Batting Average:	Sisler		Hornsby	
1917	.353	(#2 in AL)	.327	(#2 in NL)
1918	.341	(#3 in AL)	.281	
1919	.352	(#3 in AL)	.318	(#2 in NL)

As the decade drew to a close, The Cardinals were once again the weak baseball sister in St. Louis. They slipped towards last place (1918–1919), while the Browns moved up, playing close to .500 ball. The financial resources of the two teams were not even close: the wealthy ice magnate Phil Ball of the Browns versus the fragmented public ownership of the Cardinals. In 1919, the latter was so strapped financially that it couldn't afford to go south for spring training. Instead the Cards worked at St. Louis' Washington University. That year, after a hiatus of a couple of seasons, Branch Rickey replaced Hendricks and again became a field manager. By combining that job with his role as team president, he could save the team precious payroll dollars.

ALLAN SOTHORON. A spitball pitcher who was "grandfathered" and allowed to use the pitch after its ban in 1920, he came up with the Browns and finished his playing career with the Cardinals. After leading the American League in losses in 1917, Sothoron was the ace of the 1919 Browns' staff with 20 wins. The Cardinals picked him up in 1924, and he won ten games that year and the next. He is best remembered for one of his last games. He started only four games in 1926, and one was the second game on August 31 against the first-place Pirates. He beat them, 2-1, and the Cardinals swept the double-header and moved into first place. Sothoron later coached for both the Browns and the Cards; he had a reputation as a good teacher with a sharp baseball mind. He was known as "Dixie," not because he hailed from the south, but because of the way his last name sounded. (Courtesy of the Mercantile Library/UMSL.)

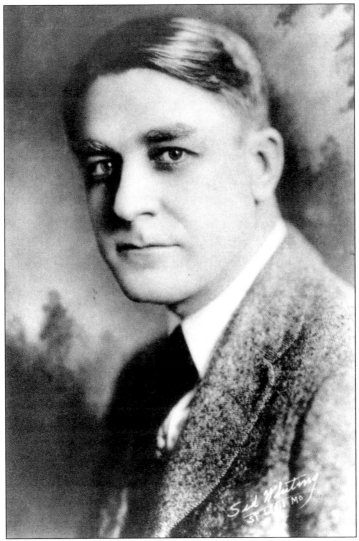

BRANCH RICKEY. He had a profound impact on baseball, and St. Louis was his stage for three decades. As a catcher, mostly for the Browns, he hit .239. As a manager for both the Browns and the Cardinals, he won less than 50 percent of his games, and his teams never finished higher than third place. As an executive, he had vision, pushed for innovations, and had a remarkable eye for talent. Rickey created the farm system that enabled the Cardinals to compete with the wealthier clubs and become almost perennial contenders. Rickey really didn't want to manage the Browns and assumed the position reluctantly after George Stovall was fired late in 1913. During the dark days of the Federal League, Rickey brought George Sisler, his pitching star at Michigan, to the Browns. In early 1916, Rickey's mentor, Bob Hedges, sold the Browns to Phil Ball; the new owner and his skipper never hit it off. A year later, after a group of St. Louis investors bought the Cardinals from Helene Britton, they needed a team president. Attorney and club officer James C. Jones called together a group of local sportswriters and asked them to write their recommendation on a piece of paper. When Jones collected and reviewed their ballots, they all had the same name: Branch Rickey. After a bumpy parting of the ways with Phil Ball, Rickey took over as Cardinal president in the spring of 1917. (Courtesy of the St. Louis Cardinals Hall of Fame Museum.)

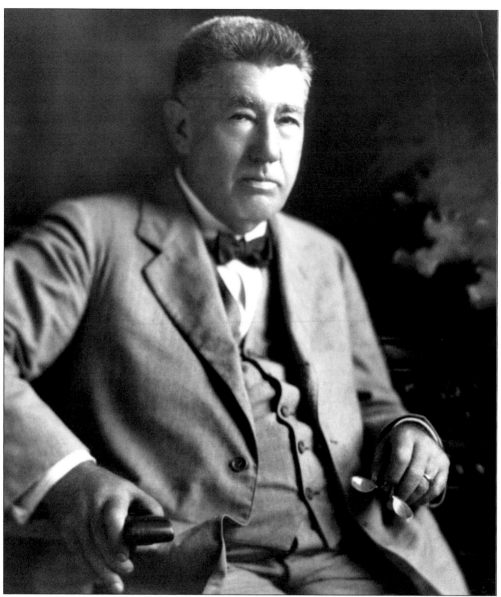

PHIL BALL. He made a fortune building ice plants and then spent another fortune trying to bring a baseball winner to St. Louis. Ball joined organized baseball by buying the Browns in early 1916 for around $425,000, after the demise of the Federal League and his St. Louis Terriers. A gruff and outspoken man, when he first met the manager of his new team, Ball said to Branch Rickey, "So you're the goddamned prohibitionist." When Rickey moved to the Cardinals a year later, it was a major loss for the Browns. Yet Ball had the good business sense to hire a talented replacement in Bob Quinn, longtime business manager of the Columbus team. In a few years, the result was the great Brown team of 1922. He continued to own the team until his death in 1933 and never came closer to the pennant than he did in 1922. Had Phil Ball refused to sub-let Sportsman's Park to the Cardinals in 1920, the history of St. Louis baseball might have developed quite differently. With significant debt and a ramshackle ballpark, the Cardinals quite possibly would have left town, and St. Louis baseball would be colored brown, not Cardinal red, today. (J.C. Strauss/Missouri Historical Society, St. Louis.)

BILL DeWitt. A long-time baseball executive and owner, he had roots in St. Louis baseball that went back to the 'teens. In 1916, DeWitt was selling soda at Sportsman's Park as a young teenager. He became an office boy for Bob Hedges and Branch Rickey that year. Rickey insisted that he continue his education. DeWitt went to night school and eventually got his St. Louis University law degree in 1931. (Courtesy of the St. Louis Cardinals Hall of Fame Museum.)

DeWitt as Manager. He followed Rickey to the Cardinals and became the team's secretary-treasurer in the 1920s and general manager in 1937. DeWitt bought the Browns in the 1940s and sold them to Bill Veeck. After working as the Yankees' assistant GM and the president of the Detroit Tigers, he became the GM of the Cincinnati Reds. A year later they won the NL pennant, and a year after that he bought the Reds. (Courtesy of the SABR-Ottoson Photo Archive.)

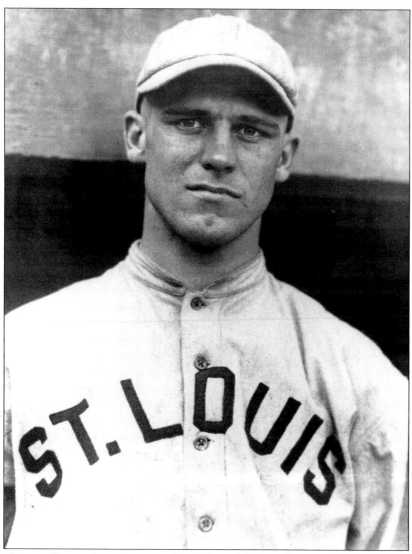

GEORGE SISLER. "Inner glow of greatness" and "justifiable ego" were two terms Branch Rickey used in describing George Sisler. One of the game's great players, he was a unique blend of ability with the bat, speed on the bases, and grace in the field. He hit over .400 in both 1920 and 1922, and his 257 hits in 1920 is still the all-time record. Only Joe DiMaggio in the American League has exceeded Sisler's 41-game hitting streak, which ended when he played against Dr. Hyland's orders because of a severe shoulder injury. "Gorgeous George" led the league in steals four times. His assists at first base reflect the ground he covered at that position—he led the league six seasons and ranks in the career Top 10 in that category. A star pitcher on Branch Rickey's University of Michigan team, he followed his skipper to the Browns in 1915, after a major controversy with Pittsburgh, which asserted a claim to him. Just as the Boston Red Sox would do with Babe Ruth in 1919, the Browns soon converted Sisler into an everyday player. Yet he always considered his 1915 2-1 pitching win over Walter Johnson as his most unforgettable moment. A consummate gentleman, on and off the field, Sisler could also be tough. He once decked teammate Bob Groom, who had taunted the "college boy." (Courtesy of the St. Louis Cardinals Hall of Fame Museum.)

HANK SEVEREID. One of the catchers on the all-time St. Louis team chosen in 1958 (Bob O'Farrell was the other), he played for the Browns from 1915 to 1925. Severeid caught 100 or more games seven times and hit .321 in 1922, one of five consecutive years above .300. He was a tough competitor who played through injuries. During the 1925 season, the Senators acquired him for the stretch run, and the Yankees did the same a year later. Both teams went to the World Series. In the 1926 Series, he appeared in all seven games the Cardinals. The Yankees released him, and he never returned to the bigs, but he played in the minors until 1937. In his obituary, Severeid was described as "the most durable catcher in the history of baseball." (Courtesy of the Private Collection of Dennis Goldstein.)

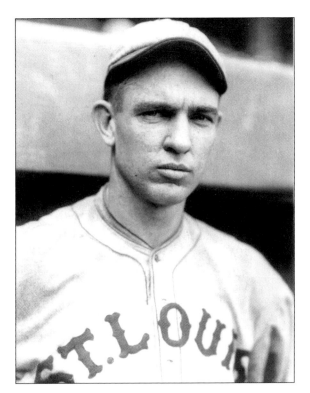

BOB GROOM. He played in the St. Louis Trolley League before turning pro in 1904 and was active as an officer in that organization long after he left organized ball. In his rookie season of 1909, with the Washington Senators, Groom led the American League with 26 losses, including 19 straight. Three years later he won 24 games. Groom jumped to the Federal League in 1914, where he lost a league-leading 20 games for the Terriers. In 1916 he joined the Browns, and in 1917 threw a no-hitter against that year's eventual world champions, the Chicago White Sox. Just a day earlier, the Browns' Ernie Koob had no-hit the Sox for a back-to-back mark that has never been matched. Groom ended the season with 19 losses, leading a league in that category for the third time in nine years. He ended his career with a record of 119-150. (Courtesy of the Private Collection of Dennis Goldstein.)

ROGERS HORNSBY. He started his career as a Cardinal and developed into the greatest right-handed hitter of all time. His career batting average of .358 is second only to Ty Cobb's .366. "The Rajah" developed and blossomed in St. Louis. Cardinal scout Bob Connery, who signed him for $500, was more impressed with the young man's fielding and hustle than with his hitting. After a couple of unimpressive minor league seasons, Hornsby reported to the Cardinals in September 1915, weighing only 135 pounds. Manager Miller Huggins mentioned that he'd have to send the youngster down to the "farm," meaning another minor league team for seasoning. Hornsby instead took his skipper quite literally and spent the off-season working and eating at his uncle's farm. When he reported back in the spring of 1916, his weight was up to 165. He was known as "the Buttermilk Kid" in those days, referring to the drink that helped him bulk up. He became a regular, playing all four infield positions in 1916. His early career coincided with that of the Browns' young star, George Sisler, but Hornsby's rise wasn't as meteoric. He was a solid hitter in the late 'teens, with batting averages of between .281 and .327. From early in Hornsby's career, the Cardinals were offered large sums of money for him. To their credit and foresight, they turned these proposals down. While the size of these offers increased in the early 1920s to six figures, Branch Rickey deserves more credit for the offers he refused in 1919, when the team's finances were so precarious. Even Miller Huggins had offers for Hornsby back in 1916. (Courtesy of the Mercantile Library/UMSL.)

MIKE GONZALEZ. A Cuban-born catcher, he had a long on-and-off career with the Cardinals, as both a player and a coach. Gonzalez spent 1915 to 1918 with the Cards, sharing catching duties with Frank Snyder. The two St. Louis backstops then went to the New York Giants in 1919. The Cardinals got Gonzalez back in a trade with Brooklyn for Milt Stock in 1924, and a year later they sent him to the Cubs for another catcher, Bob O'Farrell. The Cardinals re-acquired Gonzalez before the 1931 season, and he closed out his playing career there in 1932. When Frank Frisch was fired late in the 1938 season and coach Gonzalez was appointed interim skipper for the balance of the year, he became the first Cuban manager in the big leagues. A couple of years later, he again served as the team's interim manager after Ray Blades was fired. Gonzalez was a respected coach, even though his English was poor. In 1924, when he was asked to evaluate a young catcher by the name of Moe Berg, Gonzalez came up with a phrase that has become part of baseball lexicon, "Good field; no hit." Berg, one of the most intelligent players in baseball history, went on to a 15-year career despite a .243 lifetime batting average. "Berg can speak in 12 different languages and can't hit in any of them" was the counterpoint to Gonzalez' classic phrase. (Courtesy of the Mercantile Library/UMSL.)

A Pennant for St. Louis

would be a great commercial asset.

With two strong teams and two able leaders, a pennant is more than a possibility this year.

Wednesday, March 29th, will be ST. LOUIS BASE-BALL DAY at the Members Conference luncheon, Planters Hotel, 12:30 p. m.

The speakers and guests will be:

BRANCH RICKEY of the "Browns"
MILLER HUGGINS of the "Cardinals"
FIELDER JONES of the "Browns"
SCHUYLER P. BRITTON, President of the "Cardinals"
PHIL BALL, President of the "Browns"

Subject "What a Winning Baseball Team Means Commercially to St Louis"

All the star players of both teams will also be present and introduced to the members of the League.

Come early or you may have to take a bleacher seat.

DUNCAN I. MEIER Chairman, Members Conference.

P. S.—RAIN OR SHINE.

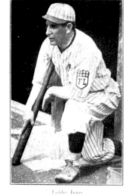

Miller Huggins

Fielder Jones

Cardinals' Line-up		Browns' Line-up	
MEADOWS	MILLER	GROOM	AUSTIN
STEEL	CRUISE	WEILMAN	LAVAN
HALL	BETZEL	SISLER	HARTLEY
DOAK	CORHAN	PRATT	DAVENPORT
BESCHER	HORNSBY	SHOTTEN	SEVEREID
BECK	SNYDER	TOBIN	DEAL
SMITH	JASPER	BORTON	KOOB
SALLEE		FINCHER	

KICKOFF TO THE BASEBALL SEASON. This postcard promoted a luncheon put on by the St. Louis business community, just before the start of the 1916 season. The war with the Federal League had ended, Phil Ball had bought the Browns, and Fielder Jones was the team's new manager. Branch Rickey still occupied a visible role as the team's business manager, as seen by his picture on the card. Baseball was reaching out to the community, emphasizing the positive economic benefits successful ballclubs generate. "What a Winning Baseball Team Means Commercially to St. Louis" is an argument that teams still make today, especially when they are reaching out for public financing. Unfortunately for St. Louis, there wasn't a lot of winning baseball in 1916. The Cardinals finished tied for last place with a 60-93 record, and the Browns ended up in fifth place, winning just over half of their games. (Courtesy of Special Collections, St. Louis Public Library.)

STREET SCENE. There were many ways of getting to the ballpark. The crowded downtown street image (Washington, looking west from Broadway) is from the 'teens. It shows pedestrians and three modes of transportation—streetcars, automobiles (dramatically rising in popularity), and horse-drawn carriages. (Courtesy of Special Collections, St. Louis Public Library.)

MARVIN GOODWIN. He was a spitball pitcher with the Cardinals from 1917 to 1922, except for the war year of 1918. Goodwin showed much promise in 1919, with 11 wins and a 2.51 earned run average. The Cardinals paid Milwaukee $15,000 in cash and players to acquire Goodwin in 1917. He flew planes for the Aviation Corps in World War I and continued to be active in the Texas National Guard, where he was a lieutenant in the Air Corp Reserves. In 1920 he was active in the battle to get spitball pitchers grandfathered from the ban on "trick" pitches, a fight in which they were successful. In 1925, he managed and had a strong year pitching for Houston of the Texas League, and the Cincinnati Reds acquired him late that year. Shortly after the end of the season, he was killed in a training flight plane crash at Houston's Ellington Field. (Courtesy of the Cleveland Public Library, Photograph Collection.)

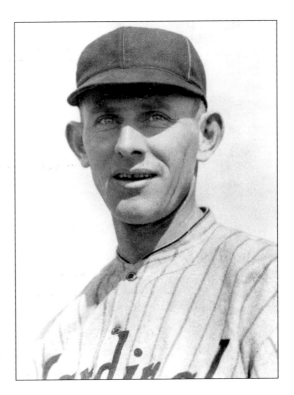

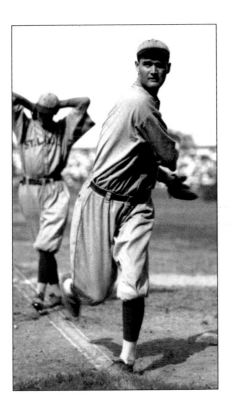

DAVE DAVENPORT. "The attitudinous [sic] Dave has the temperament that is supposed to go with a star without being a stellar performer." So wrote J.V. Fitzgerald, in the *Washington Post*, March 7, 1920. In 1915, for the St. Louis Terriers, Davenport led the Federal League in shutouts (10), complete games (30), strikeouts (229), and an amazing 392 2/3 innings pitched. Davenport even pitched both ends of a double-header, winning and losing by the score of 1-0. Fielder Jones called him the best pitching prospect he'd ever worked with. He won 39 games in his first three years with the Browns, 1916–1918. He pitched *and won* two complete games in one day against the Yankees in 1916. The *St. Louis Times* predicted 20 wins for him in 1919. The 6-foot, 6-inch hurler had a temper and enjoyed his alcohol, both of which got the better of him near the end of that season. The results were a 2-11 record with a high earned run average, and a suspension for "not following training rules" in late August. When he reported back, he pulled a knife on manager Burke and business manager Quinn. Though only 29 years old, Davenport never again pitched in the bigs. (Courtesy of the Walter P. Reuther Library, Wayne State University.)

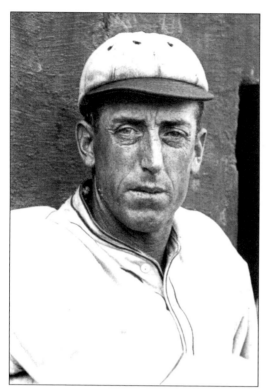

EDDIE PLANK. One of the greatest southpaws in baseball history, he came to St. Louis just shy of the age of 40 and won 21 games for the 1915 Terriers and 16 games for the 1916 Browns. Then, in his final year, Plank had a 1.79 earned run average with the 1917 Browns. His final game was a 1-0, 11-inning loss to Walter Johnson. He was then traded to the Yankees in the Del Pratt/Urban Shocker deal, but chose to retire instead. Gettysburg Eddie graduated from the college of that name, and he gave tours of the famous battlefield after he retired. Plank wasn't a favorite of sportswriters—he was so quiet and studious. He also wasn't a favorite of opposing hitters—he fidgeted on the mound, talking to the ball and to himself, working so slowly that he drove batters to distraction. (Courtesy of the Mercantile Library/UMSL.)

TWO MASTERS: PLANK AND WALSH. One of the few Hall-of-Famers who did not play in the minors, Plank (left) was a finesse pitcher whose easy delivery contributed to his longevity. He was known for his "crossfire" pitch, a sidearm throw that crossed the plate at an unusual angle. Until he jumped to the Federal League, Plank had a 14-year career as the heart of the Philadelphia Athletics' pitching staff, from the 1902 and 1905 winners to the powerhouse 1910–1914 teams. He won almost 25 percent of the teams' victories during those years. His 326 wins were the most for a lefty until Warren Spahn broke the mark in 1962. He was elected to the Baseball Hall of Fame in 1946. Here Plank is seen with spitball pitcher Ed Walsh of the Chicago White Sox, an odd couple—the colorless Plank and the magnetic Walsh—yet both masters of the mound, near the end of their glorious careers. (Courtesy of the Chicago Historical Society.)

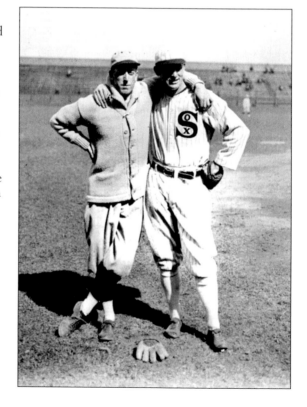

THE KNOT-HOLE GANG

The Half-Defiant, Half-Pitiful Cry "I'm always a movin' on, sir. I've been a movin' on, sir, ever since I was born. Where can I move to, sir, more nor I do move?"—is the cry of poor Joe, the street waif in Dickens' "Bleak House," which is not confined to London nor to Dickens' time—it is heard in St. Louis to-day. The above is a picture of the "KNOT-HOLE" Gang—never get to see a baseball game except through a knot hole in the fence—never have a place to play ball except on a plot of ground about as big as your hand, usually filled with tin cans, in the rear of a tenement—baseball bats they have none—a piece of lumber usually serves as a bat—for a ball they use a piece of automobile tire wrapped with cotton twine.

THE GREATER BOY MOVEMENT

is involved in the purchase plan of the St. Louis Cardinal Baseball Club—to do work for boys you must find the point of contact with the boy. We believe we have found it in baseball. We believe that the boys of this city are the best capital that St. Louis has and we know that the boy of to-day is the man of to-morrow—into his hands must necessarily be committed all the positions of trust and responsibility that this municipality may have to offer. Boy stuff is the only raw material in the world out of which man stuff can be made.

THE CARDINAL IDEA

is to give to St. Louis a pennant-winning baseball team—and all that that means in the advertising of the city—and to give with each fifty dollars' worth of stock a pass to one of these boys for every week-day game played by the Cardinals on the home grounds this season. It also means to give them baseball diamonds in the districts in which they live and balls and bats to play with. In a nutshell the "CARDINAL IDEA" means just two things—to develop a winning baseball team for St. Louis and to develop a higher boy life.

LET'S BUY THE CARDINALS

Four hundred thousand dollars of preferred stock—bearing six per cent—sharing first in dividends—is being offered at twenty-five dollars a share. The demand is active—we predict it will go to a premium by March thirty-first. Buy fifty dollars' worth of stock and get a pass for a member of

"THE KNOT-HOLE GANG"

—————— COUPON ——————

Tear out this coupon and mail to James C. Jones, Trustee, 2167 Railway Exchange Building, City.

Tell me all about this Cardinal proposition.

Maybe I will buy a few shares—invest, say, about $

Signed .

Business Address

THE KNOTHOLE GANG. The concept was both clever and simple: build a long-term fan base by subsidizing the admission of youngsters into the ballpark. The name came from the way kids used to watch ballgames—through knotholes in the wooden fences. The Cardinals' new ownership group developed the idea early in 1917; it also added excitement and publicity for the public sale of stock. Every $50 of stock purchased generated a season's pass for a youngster to a weekday game. Attendance was naturally higher on weekends, which were excluded.

The Cardinals, led by attorney James Jones, presented the idea to the public before Branch Rickey came on board as president. Yet it was Rickey who really made it a success, by linking up the stock purchasers, mostly well-to-do people whose children didn't need free passes, with the needy kids. By July 1917, the Cardinals had enrolled nearly 125 clubs in the program, from the YMCA and Boy Scouts to church and synagogue groups. The Knothole Gang became an enormous success, with more than 10,000 members. Note that the ad suggests each share of stock cost $25, not $50, as has been commonly reported. (*Globe-Democrat*, March 11, 1917)

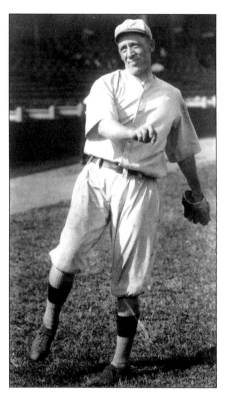

LEON "RED" AMES. At the age of 35, he won 15 games for the 1917 Cardinals and was a big reason for the team's surprising third place finish that year. In both 1916 and 1917, manager Huggins frequently used him as a relief pitcher. Ames had gone 22-8 for the 1905 world champion New York Giants, the team with which he won three pennants. A cheerful fellow with a positive attitude, he earned the nickname "Kalamity" for heartbreaking opening day losses in 1909, 1910, and 1911. In the '09 opener, he had a no-hitter for 9 innings before losing to Brooklyn in the 13th, 3-0. (Courtesy of the Mercantile Library/UMSL.)

CHARLIE GRIMM. Branch Rickey was a brilliant evaluator and predictor of talent, but some did "get away." Charlie Grimm was one such player. A graduate of St. Louis' Kerry Patch, he had a brief stay with the Athletics, when he was only 17 years old and had never been in the minors. After a year in Durham, he joined the 1918 Cardinals, who needed players during the war year. Grimm batted only .220 in 50 games, and St. Louis then sold him to Little Rock. He went on to a 20-year career as a first baseman, mostly with the Chicago Cubs. A natural comedian and easygoing fellow, "Jolly Cholly" became an institution at Wrigley Field, home of the Cubs. He managed the team for many years, winning pennants in 1932, 1935, and 1945, the Cubs' last NL pennant. (Courtesy of the Mercantile Library/UMSL.)

JOE GEDEON. A friend of Chicago Black Sox infielder Swede Risberg, Gedeon was banned from baseball for his "guilty knowledge" of the 1919 World Series conspiracy. He came forward to collect the $20,000 reward White Sox owner Charles Comiskey had offered and agreed to testify before the grand jury. He didn't get the money and instead received a lifetime ban from the game.

He went to the Browns with Urban Shocker in 1917 as part of the Del Pratt trade and started to blossom. Gedeon led all AL second basemen in fielding percentage in both 1918 and 1919. In 1920, he was one of the best in the game at his position—he had 177 hits, 33 doubles, and a .292 batting average. That turned out to be his final season. After his testimony, Gedeon was not immediately banned from the game when the Black Sox were disqualified, late in the 1920 season. The Browns still released him, however, and no other team came forward with any offer. A year later, when Gedeon was playing exhibition games against Pacific Coast League players, Commissioner Landis received inquiries from the players about the legality of competing in a game with Gedeon. It was then that Landis took care of loose ends and formally banned Joe Gedeon from organized ball. (Courtesy of the Cleveland Public Library, Photograph Collection.)

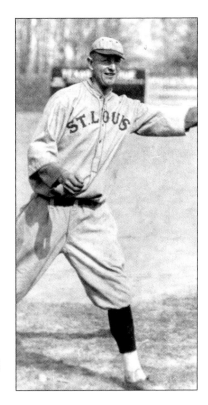

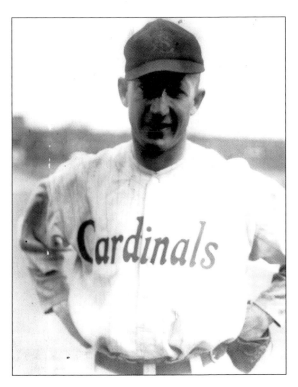

GENE PAULETTE. An infielder with both the Browns and the Cardinals in the late 'teens, he was involved with gamblers and banned from baseball by Commissioner Landis in early 1921. The incriminating evidence was a letter he wrote that surfaced. When he didn't pay off a loan to gamblers and was asked to "throw" games, he didn't agree, yet he didn't refuse involvement with them either. Instead he asked to borrow more money and gave the gamblers the names of two teammates who could "be bought." Their identity has never become known. (Courtesy of the Mercantile Library/UMSL.)

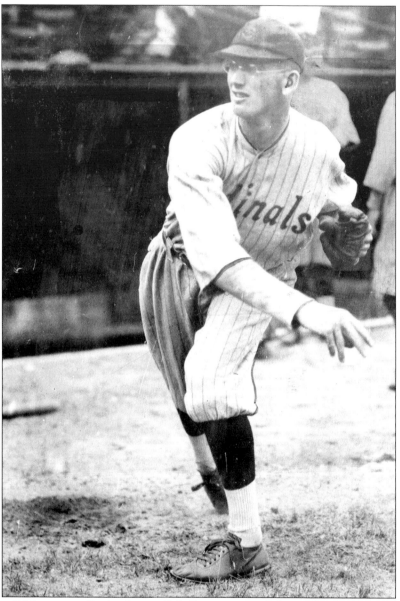

LEE "SPECS" MEADOWS. Cardinal scout Bob Connery signed the pitcher for $500, making him the first modern major leaguer who wore glasses. Miller Huggins thought his scout had taken leave of his senses. There was a lot of bias against bespectacled players in those days: the concern that a line drive would shatter the glasses and injure the man, as well as the feeling that a pitcher who can't see well couldn't get the ball over the plate very well either. His four and one-half years in St. Louis had ups and downs. Thirteen wins in his 1915 rookie season offset the loss of Pol Perritt that season, yet a year later "Spec" led the league in losses with 23, despite an earned run average slightly better than the league average. His 15-9 mark in 1917 helped lead the Cards to a surprising third place finish. During the 1919 season, he was traded to the Phils. A spitballer early in his career, he was not one of the 17 pitchers grandfathered and allowed to throw the spitter after it was banned in 1920. Here is a shot that shows his graceful, sweeping motion. (Courtesy of Transcendental Graphics.)

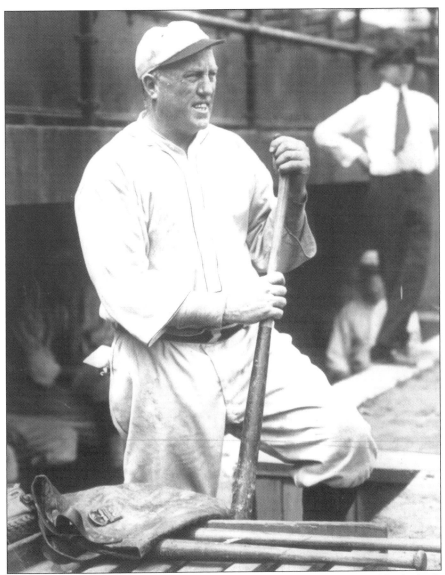

JIMMY BURKE. Who was the man, other than Branch Rickey, who managed both the Browns and the Cardinals in the first quarter of the 20th century? He was known as "Goose Hill" Jimmy because he grew up and played sandlot ball in St. Louis' Goose Hill area, which ran from 14th to Blair and from Buchanan to Branch. Burke played on the neighborhood's Shamrock team along with Jack O'Connor as early as 1892, when Burke was 17 years old. Burke, the Cardinals' third baseman, managed the team during the tumultuous 1905 season. He replaced Kid Nichols mid-season and was relieved himself before the year was out, when owner Stanley Robison tried his hand at managing. Then, in the late 'teens, Burke was the skipper of the Browns (1918–1920), as they were rising to the first division. As a player, he was a hustling firebrand. He and Jesse Burkett were known as the best "cussers" on the Cardinals. As the Browns' manager, Burke was a rah-rah guy, called "Sunshine Jimmy," very different from the dour Fielder Jones (who preceded him) and the reserved Lee Fohl (who followed him). He later coached for the Cubs and the Yankees, before being felled by a paralyzing stroke that left him an invalid for the last decade of his life. (Courtesy of the Mercantile Library/UMSL.)

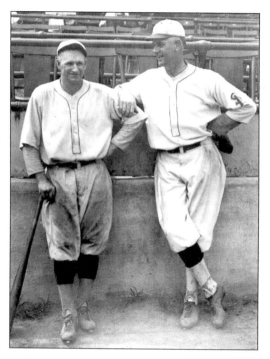

ALBERT "LEFTY" LEIFIELD. He started in the Alton, Illinois Trolley League and returned to St. Louis at the end of his career as an occasional pitcher (1918–1920) and coach (1918–1923) for the Browns. In his first six full seasons in the bigs, he was one of the game's best pitchers, winning 103 games for Pittsburgh. "Lefty" had many classic match-ups with the ace of the New York Giants, Christy Mathewson. In 1906 Leifield was involved in a double one-hitter with Mordecai Brown. The Pirates lost, with Leifield getting the only hit off Brown. In 1912, arm trouble set in, and he was traded to the Cubs. He spent a few years in the minors and then returned to the bigs with the Browns. He won only 15 games after the Pirates traded him, though he was only 28 at the time. One of those wins was a one-hitter in 1919. He is seen here (on the right) with the other Browns' coach of the late 'teens and early 1920s, Jimmy Austin. (Courtesy of *The Sporting News*.)

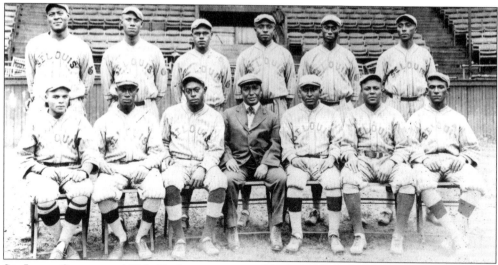

ST. LOUIS GIANTS, c. 1916. Black tavern owner Charlie Mills (in middle of front row, in suit) founded the team in 1907. While there was not a structured Negro league until 1920, this team was a collection of enormous talent. Bill Gatewood (back row, far left) played on more than a dozen teams in his career, not all that unusual for black players at the time. He was a good pitcher and hitter. In 1922 he was the manager of the St. Louis Stars and the man who gave James Bell the nickname "Cool Papa." Bill "Plunk" Drake (back row, second from left) was a tough pitcher who kept hitters off-balance. He traveled a lot, playing even on white semi-pro teams in North Dakota. Frank Warfield (front row, second from left) was a smart second baseman and fast contact hitter. Jimmy Lyons (front row, second from right) was a great base runner and drag bunter. He became most well known for his years with the powerful Chicago American Giants in the early 1920s. (Courtesy of the Missouri Historical Society, St. Louis.)

FIVE

The Rise of Baseball in St. Louis

1920–1925

St. Louis' pro baseball teams became contenders for their leagues' titles. With the exception of the 1924 Cardinals, they both were close to or above .500 each of these seasons. In 1922, both clubs were in the pennant race deep into the summer, and for a few heady days that August, both occupied first place. The Browns fell just one game short of the Yankees and the pennant that season, and the Cardinals finished in third place, just eight games behind the New York Giants. St. Louis continued to be an American League city, as the Browns outdrew the Cardinals in five of these six seasons. They also finished in the first division five times.

At the time, 1920 did not seem to be one of the most significant years in St. Louis baseball history, yet it was. First, as the year began, one man emerged from the Cardinals' ownership group to consolidate control. Sam Breadon was an automobile dealer who bought $200 of stock in the team in 1917. He soon increased his holdings to $2,000 and then loaned the team $18,000. Why? To protect his investment, when the team was in danger of defaulting on a payment to Helene Britton. He became team president in December 1919 (Branch Rickey became vice-president) and reduced the team's large board to a more manageable seven members. Civic ownership of the team was ended for all practical purposes. Decision-making was streamlined, and the team was able to act more clearly and quickly. By 1922, Breadon owned a majority of the stock, and one year later he controlled more than 75 percent of it.

Second, in June 1920, the Cards played their last game at their ramshackle ballpark. Known as League Park early in the century, and then Robison Field after the death of both Frank and Stanley Robison, the name was changed to Cardinal Field in 1917. Breadon and Rickey had convinced Phil Ball to let them become tenants at his Sportsman's Park for $35,000 a year.

Breadon soon sold his old ballpark property to the city's Board of Education for $200,000. (A few years later, Beaumont High School was built on the site.) The team then sold another part of the property to the city's public transit company for $75,000. Mrs. Britton had sold her club (and assets, which included the ballpark and property) for $350,000 (the original $375,000 included legal fees of $25,000, which attorney Jones later waived). The new owners recouped more than 75 percent of that price just a few years later. $275,000 was an enormous amount of money in 1920. It allowed the team to pay down debt and still have a substantial amount of cash left over.

At the same time, Branch Rickey wanted his Cardinals to compete with wealthier teams for promising minor league players. He decided to bring to fruition what he and Robert Hedges had visualized back in 1913: the concept of a formal and structured farm system, whereby the Cardinals would acquire minor league teams that would feed players up to St. Louis. The plan was remarkably simple: sign many players at low salaries, place them in different levels of minor league teams, and let the talent develop and bubble up. Since the Cardinals would own the teams, they would not have to get into bidding wars with other, richer teams. With the money they had from the sale of their ballpark property, the Cardinals bought the Ft. Smith, Arkansas

and Rochester and Syracuse, New York teams. Just a couple of years later, the first players from this farm system took their place in the Cardinal lineup: Jim Bottomley and Ray Blades.

Nineteen-twenty was also significant year for black baseball in general and in St. Louis in particular. The Negro National League, consisting of eight midwestern teams, was created and provided structure. While barnstorming continued even during the season, there were schedules and rules against contract jumping. Charley Mills' St. Louis Giants was one of the eight teams, but he sold out after the 1921 season—not before a spirited pennant race with the Giants falling just short of the pennant. And not before a member of the Giants, Oscar Charleston, put together one of the finest years in Negro League history. He was in the midst of a long and spectacular career, one that would result in his election to the Baseball Hall of Fame in 1976.

The team was re-named the Stars and moved from a small park on North Broadway to one that held 10,000 fans on Compton and Market. In their first three seasons (1922–1924), the Stars finished in the middle of the pack. At the top, the Kansas City Monarchs were replacing the Chicago American Giants. Something significant was going on at the player level in St. Louis. A young pitcher, who would soon be converted to a position player, arrived on the scene and began to give black fans someone to cheer for. His name was James "Cool Papa" Bell. In 1925, with a new split-season format in place, the Stars and Bell won the second half and faced Kansas City in the playoffs. The Monarchs eked out a 4-games-to-3 victory. The difference was a man by the name of Bullet Joe Rogan. He won all four of their victories and hit .455.

There were also fall exhibition games between organized baseball's teams and Negro League teams. In 1920 and 1921 the Cardinals (without Rogers Hornsby) beat the St. Louis Giants in series. A year later, the new Stars' team faced off against the Detroit Tigers (minus Ty Cobb and Harry Heilmann) and won that series. While the money was important for both sides, there was more to prove and more at stake for the black teams.

The Browns and Cardinals of the early 1920s were both imposing offensive teams. Consider the batting averages and league rank:

Batting Average:	Cardinals	Browns
1920	.289(1st)	.308(1st)
1921	.308(1st)	.304(3rd)
1922	.301(3rd)	.313(1st)

Superstars Hornsby and Sisler drove these numbers with spectacular hitting performances in Sportsman's Park virtually ever day of the baseball season—when the Browns were on the road, the Cards were home, and vice versa:

Batting Average:	Hornsby	Sisler
1920	.370 (1st)	.407 (1st)
1921	.397 (1st)	.371 (4th)
1922	.401 (1st)	.420 (1st)

While George Sisler did not replicate those numbers after 1922, Rogers Hornsby did. He led the National League in hitting for another three years in a row, 1923-1925, with batting averages of .384, .424, and .403.

Had the two teams' pitching talent been equally strong, there might have been some pennants during these years. In only one of these seasons did a St. Louis club have one of the league's best earned run averages: the 1922 Browns, who finished one game short of the pennant, actually had major league baseball's lowest earned run average that year.

Both teams fell back to fifth place in 1923. The Browns lost George Sisler for the entire year, due to a sinus condition that caused a serious eye ailment. They also lost their capable and unassuming manager, Lee Fohl (who had replaced Jimmy Burke in 1921), and their talented

business manager Bob Quinn. Fohl was fired, ostensibly over the Dave Danforth controversy (see further), and Quinn left to assemble the ownership group that bought the Boston Red Sox from Harry Frazee. His replacement, Billy Friel, simply did not have the background that Rickey and Quinn had.

In both instances, the hand of owner Phil Ball was evident. His interference frustrated Quinn, and without him, Fohl no longer had a buffer between himself and his owner. George Sisler became the skipper for the 1924 season. His eye condition improved, yet he never again approached the high level of performance he had in the past. Like Browns' star Bobby Wallace more than a decade earlier, managing was not a role Sisler particularly enjoyed or was best suited for.

With the Cardinals, as different as the personalities of Sam Breadon and Branch Rickey were, Breadon recognized Rickey's strengths and especially the potential of the farm system, which he funded freely. He gave Rickey both the authority and the limelight that his vice-president needed to thrive and be effective, something Phil Ball could not do. There was one exception. In late May 1925, with the Cardinals floundering in last place, Breadon relieved Rickey of his managerial responsibilities, which he turned over to his star player Rogers Hornsby. While it was a difficult blow to Rickey at the time, it allowed him to focus on what he did best, in a position we today know as the "general manager."

As 1925 drew to a close, the prospects of both teams seemed similar. The Browns had just gone 82-71 (good for third place), after two seasons with 74 wins. Phil Ball felt so optimistic about his team's prospects that he undertook a major expansion of Sportsman's Park that winter, increasing the capacity from 24,000 to 34,000. The Cardinals improved after Hornsby took over and finished 77-76, after averaging 72 wins the two previous seasons.

Two of the greatest hitters ever were player-managers of their teams, a popular combination at the time. Detroit's Ty Cobb, Cleveland's Tris Speaker, and Washington's Bucky Harris had similar roles on their clubs. After Washington won the American League pennant in 1924 and repeated in 1925, there were only two of the sixteen major league teams who had not won a pennant in this century. Both were in St. Louis, yet the prospects were positive for both. Even the city's Negro League team, the Stars, seemed to be on the verge of the Negro National League pennant.

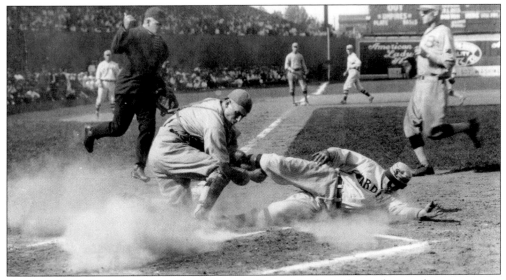

EARLY 1920S ACTION SHOT, SPORTSMAN'S PARK. A close play at home plate in a game between the Cardinals and the Boston Braves. It appears that Braves' first baseman Walter Holke is moving up on the play. This is a good, early action shot from Sportsman's Park, though the runner is not identified. (Courtesy of the Private Collection of Dennis Goldstein.)

THESE MEN MADE THE
1910 ST. LOUIS AUTO SHOW

The committee which planned and executed the 1910 Show is composed of officers and directors of the

St. Louis Automobile Manufacturers' and Dealers' Association, Inc.

BREADON AUTO SHOW CARD. Here is a flyer from the 1910 St. Louis Auto Show, before auto sales really took off. A young Sam Breadon in pictured in the upper left oval. Breadon's foresight and guts were evident years before he came to baseball. Born into poverty in New York City, he moved to St. Louis in his 20s and made money as an entrepreneur during the 1904 World's Fair. He became a partner in a Ford agency long before the automobile boom and soon was a wealthy man. (Courtesy of the Breadon Collection/Missouri Historical Society, St. Louis.)

"The other figure in perhaps the greatest two-man combination baseball has ever known."
—Sportswriter Roy Stockton

SAM BREADON. "Lucky Sam" initially bought $200 of Cardinals' stock in 1917, and as he increased his stake, he increased his involvement and control. He developed a remarkable relationship with Branch Rickey. Breadon had the vision to see the genius in Rickey's ideas and to fund them, especially the farm system. In 28 years as the owner of the team, he won nine pennants and six world championships. Breadon was not afraid of exercising the ultimate prerogative of an owner—firing those who reported to him. In the spring of 1925, he fired his first manager, Branch Rickey. The most famous such move was his trading away player-manager Rogers Hornsby, shortly after the Cards won the 1926 World Series. He would later fire other managers who took the Cardinals to the World Series: Bill McKechnie, Gabby Street, and Frank Frisch. (Courtesy of the National Baseball Hall of Fame Museum, Cooperstown, New York.)

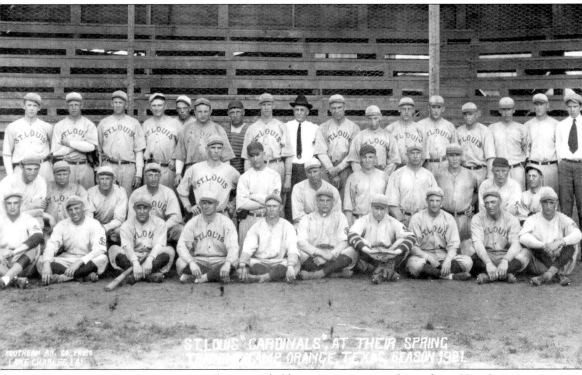

1921 St. Louis Cardinals. This remarkable spring training photo from Hot Springs, Arkansas, has 39 people, many of whom did not "make the cut" for the regular season. The picture includes two young sportswriters discussed elsewhere in this book: John Sheridan (back row, far right) and Sid Keener (middle row, far right). The ball players, from left to right, are as follows: (front row) Unknown, Arthur Riviere, Clarence Mueller, Jake May, Karl Adams, George Gilham, Walter Irwin, Cliff Heathcote, Mike Kircher, and Frank Dodson; (middle row) Paul Eiffert, Pickles Dillhoefer, Lou North, Burt Shotton, Roy Walker, Adolph Pierotti, Walt Schulz, unknown, unknown, unknown, Tommy Madden, and Sid Keener; (back row) Hal Janvrin, Joe Schultz, Jesse Haines, Lew McCarty, Ferdie Schupp, Verne Clemons, Joe Sugden, Austin McHenry, Branch Rickey, Jack Fournier, John Lavan, Specs Toporcer, Rogers Hornsby, Bill Pertica, unknown, unknown, and John Sheridan. While many of these men are quite obscure, only two of them (Eiffert and Dodson) never played a regular game in the big leagues.

Branch Rickey had an uncanny eye for talent. Time and again, Rickey traded away players while they still had value, but were on the downward side of their careers. Time and again, he had more than adequate replacements at hand. So often he also saw potential and value in players that others had given up on—men like pitcher Jeff Pfeffer and outfielder Les Mann in the early 1920s. Rickey didn't let relationships cloud his decision-making. In 1926 he traded away his favorite player, Heinie Mueller, for Billy Southworth.

"The Mahatma," as Rickey later became known, worked for two owners who were radically different than he was in personality and style. Phil Ball of the Browns and Sam Breadon of the Cards were not easy men to work for. Rickey left the former after only a year; he and the latter stayed together for more than 20. Ultimately, in 1942, even Sam Breadon and Rickey parted ways. Breadon's Cards kept winning, and Rickey went on to build a powerful franchise in Brooklyn, where he broke the "color barrier" with Jackie Robinson. (Courtesy of the St. Louis Cardinals Hall Of Fame Museum.)

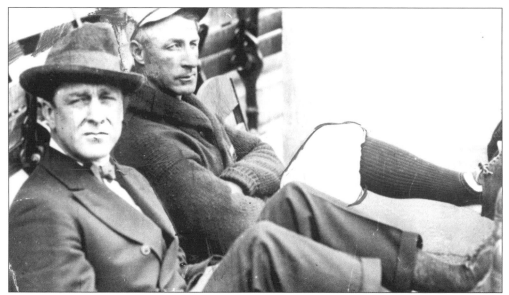

BRANCH RICKEY. When Sam Breadon fired him as manager early in 1925, Rickey was upset enough to sell his stock. The man with whom he had tussled in the clubhouse more than once, Rogers Hornsby, was taking his place. Ultimately, the change enabled Rickey to focus his genius full-time on his front-office roles, including building the pipeline of players and keeping the talent flowing. His farm system (eventually adopted by other teams) had a profound effect on the game. It gave new meaning to the purpose of the minor leagues, and new purpose to the hopes of St. Louis baseball. He was elected to the Baseball Hall of Fame in 1967. Here is Rickey (left) with Burt Shotton, c. 1924. (Courtesy of the SABR-Ottoson Photo Archive.)

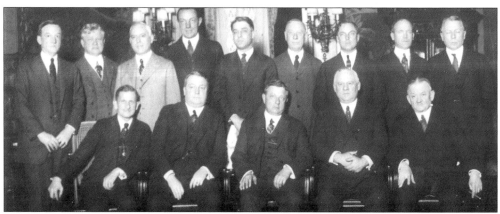

NATIONAL LEAGUE OWNERS, c. 1920. Baseball's winter meetings, which brought together the owners of the major leagues, typically took place in December. Each league had its own sessions, and there also were joint meetings. Sam Breadon (back row, third from right) had recently assumed the presidency of the Cardinals, and his vice-president and manager Branch Rickey (back row, fifth from left) was beginning to develop his farm system at this time. The 1920 National Agreement dropped the ban on major league clubs owning minor league teams. Brooklyn's owner Charlie Ebbets is in the back row (second from left) and the "bookends" of the front row are two long-time owners, Barney Dreyfuss (Pittsburgh, far left) and Gary Herrmann (Cincinnati, far right). New York Giants' manager and part-owner John McGraw is also in the front row (second from right). (Courtesy of Michael Mumby.)

BURT SHOTTON. In 1919, Branch Rickey acquired him for the Cardinals. Shotton was 34 now, his speed was gone, and he became more of a coach and Sunday manager for Rickey than an everyday player. He coached for the Cards from 1921 to 1925, departing just before they won their first pennant. A modest and unassuming man, Shotton later managed the Phillies and various minor league clubs for the Cards. In 1947, with Rickey running the Brooklyn team's front office, he pulled Shotton out of semi-retirement to manage the Dodgers during Leo Durocher's one-year suspension. Shotton also managed them from the middle of the 1948 season through 1950. The Dodgers won the '47 and '49 pennants and lost the 1950 pennant on the last day of the season. These two baseball men worked together in the 'teens, 1920s, and 1940s. Here are Rickey (on the left) and Shotton in the late 1940s. (Courtesy of AP/Wide World Photos.)

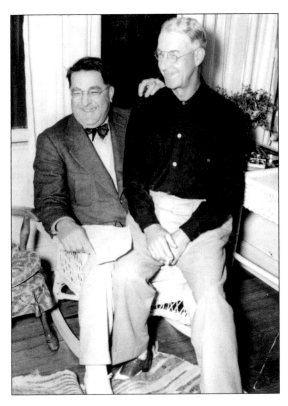

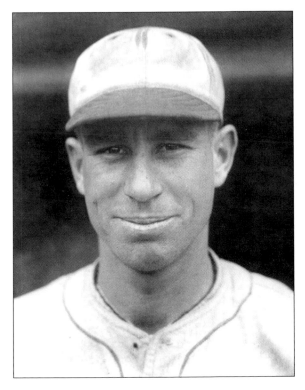

EMILIO PALMERO. One of the first Cubans in baseball, he was discovered on the island by John McGraw. Though known for his control, Palmero walked nine men in his 11$^2/_3$ innings with the Giants in 1915. Nineteen-twenty-one was his one season in St. Louis, where he went 4-7 with the Browns. At the end of the year, he was one of 11 men the Browns sent to Columbus for Dave Danforth. Palmero spent a number of years in the minors, with his high point coming in 1927. He went 14-5 for Casey Stengel's Toledo Mud Hens, who won the American Association pennant and then beat Buffalo, the International League champion, in the Junior World Series. Palmero won two games in that series. That performance gave him one last ticket to the bigs—he appeared in three games with the 1928 Boston Braves. (Courtesy of Michael Mumby.)

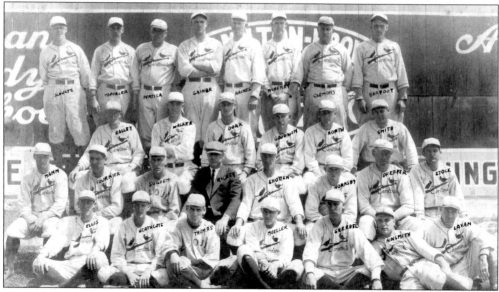

1922 St. Louis Cardinals. Branch Rickey is in the suit, sitting between his coaches Joe Sugden (on left) and Burt Shotton (on right). Milt Stock (second row, far right) was the Cards' third baseman for five years and hit above .300 for four straight seasons, 1919 to 1922. He was traded to Brooklyn in an early 1924 deal that brought catcher Mike Gonzalez back to the club. Jack Smith (third row, far right) was a terrific and often overlooked player who played for the team for more than a decade. He also hit well over .300 four years in a row, 1920 to 1923. One newspaper account said of this excellent ballplayer who didn't stand out in a crowd, "Smith is the finest example of the ordinary player." (Courtesy of the St. Louis Cardinals Hall of Fame Museum)

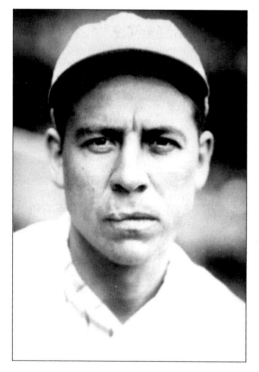

Jack Fournier. A terrific hitter who was not known for his glovework, Fournier was the Cardinals' first baseman from 1920 to 1922, averaging .317. When the Cardinals signed him for 1920, Rickey had a meeting with his new first baseman and asked him if he smoked, drank, or went out at night. When Fournier replied in the affirmative to all three, Rickey replied, "Judas Priest, what kind of player are you?" Fournier replied, "A very good one." Rickey laughed and told him to report. He later scouted for a number of teams, including the St. Louis Browns in the late 1930s and 1940s. (Courtesy of Transcendental Graphics.)

"PICKLES" DILLHOEFER. He had only 600 major league at-bats, yet he is remembered in baseball lore: for being a footnote in a blockbuster trade and for his tragic death. Late in 1917 the Phillies sent the best pitcher in baseball, Grover Cleveland Alexander, and his catcher Bill Killefer, to the Chicago Cubs for $55,000 and a couple of players. Dillhoefer, with only one season under his belt, was one of those players. The cash exceeded the $50,000 the Red Sox got for Tris Speaker a year earlier. "Pickles"—his name was a play on word of part of his last name, "Dill"—came to the Cardinals with Milt Stock a year later. Dillhoefer had two decent years as a back-up catcher in 1920–1921. Early in 1922 he married a girl from Mobile, Alabama. Dillhoefer soon became ill with the flu, which turned into pneumonia, and he died in late February. His funeral was held in the same church in which he was married a few weeks earlier. (Courtesy of Michael Mumby.)

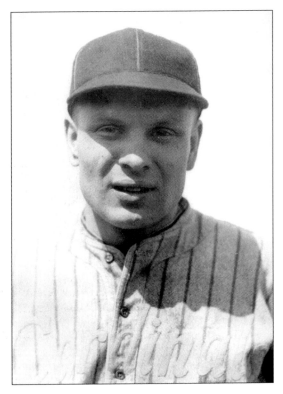

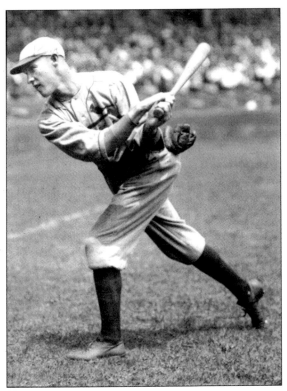

AUSTIN MCHENRY. Struck down by a brain tumor at the age of 27, he was emerging as one of the game's bright stars. In his fourth year with the Cardinals, he had a breakout season: a .350 batting average with 201 hits and 37 doubles. He also drew raves for his grace in the outfield. *The Sporting News* wrote, "He ambles over the ground with a stride that makes it appear he is just out for practise." He was then struck down by tragedy about a decade after another Cardinal prospect, Arnold Hauser, had been hit by misfortune. Early in the 1922 season, McHenry had trouble judging fly balls. Doctors eventually found a brain tumor, and he died before the end of the year. Branch Rickey often referred to McHenry as one of the best outfielders he ever saw. (Courtesy of the St. Louis Cardinals Hall of Fame Museum.)

JESSE HAINES. After he posted a 21-5 record for Kansas City in 1919, the Cardinals bought Haines for $10,000. The team was so financially strapped that Branch Rickey had to persuade the owners to borrow the money from the bank. More than a dozen of the team's shareholders had to co-sign the note. It was then that Rickey committed to making the farm system a reality. It succeeded so well that Haines was the last player the team had to buy for more than 25 years. He became the team's workhorse right away, pitching more than 300 innings in 1920. Ironically, in his worst season, 1924 (when he went 8-19), he threw a no-hitter. "Pops" went on to an 18-year career with 210 wins for St. Louis, second only to Bob Gibson. He was elected to the Baseball Hall of Fame in 1970. (Courtesy of Brace Photo.)

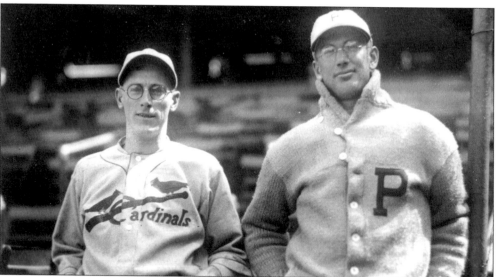

"SPECS" TOPORCER. A utility infielder who played all four positions for the Cardinals from 1921 to 1928, he went straight from the sandlots to the bigs. He played in more than 100 games only once, in 1922, when he hit .324. Toporcer, the first infielder to wear glasses, went on to great success after he left the majors in 1928. He played on four Rochester pennant winners and was twice the International League's Most Valuable Player (1929 and 1930). Like Chick Hafey, he had eyesight problems, only much worse. Despite numerous operations, Toporcer went totally blind in 1951, from a detached retina. He was managing Buffalo at the time. His life story was made into a TV movie, in which Toporcer played himself. He also wrote a book, *Baseball from the Backyard to the Big League.* He is seen here (on the left) with former Cardinals' pitcher Lee Meadows, in a rare image for the 1920s, two bespectacled ballplayers. (Courtesy of Michael Mumby.)

ED "JEFF" PFEFFER. An anchor on the Brooklyn Robins from 1914 to 1920, including two pennant winners, he came to the Cardinals in 1921 and had a fine 19-12 comeback season in 1922 at the age of 34. He actually started his career in St. Louis, when he appeared in two games for the 1911 Browns, but they didn't hold onto him. In June 1921, Branch Rickey sensed that something was left in Pfeffer's arm, though he was 1-5 at the time of the trade. In his first season-and-a-half with St. Louis, he went 28-15. Brooklyn manager Wilbert Robinson nicknamed his big (6'3", 210 lbs) pitcher "Jeff," after former heavyweight boxing champ James Jeffries. He was known for his brushback pitches, and in a spring training 1920 game, he almost killed the Yankees' Chick Fewster with a ball to the head. (Courtesy of Brace Photo.)

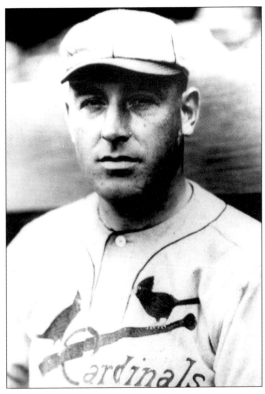

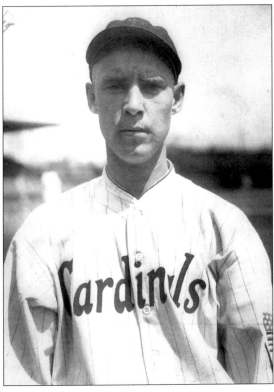

BILL SHERDEL. He pitched for the Cardinals for a dozen years (1918–1930), as they rose from an average team with good hitting to a balanced one that won pennants. Early on, Branch Rickey used Sherdel as a relief pitcher: from 1919 to 1921, 91 of his 117 appearances were in relief. He won 86 games for the Cards from 1918 to 1925, including a league-best .714 winning percentage in 1925. He was not an overpowering pitcher; he had an effective slow ball and was nicknamed "Wee Willie" for his light weight (160 lbs). Sherdel is remembered for one of the Fall Classic's memorable moments, which came in Game 4 in 1928. He threw a quick-pitch third strike past Babe Ruth, but the umpire ruled that quick pitches (which were legal in the National League) were not allowed in the Series. Ruth then hit Sherdel's very next pitch for a home run, and New York was on its way to a four-game sweep. (Courtesy of the Mercantile Library/UMSL.)

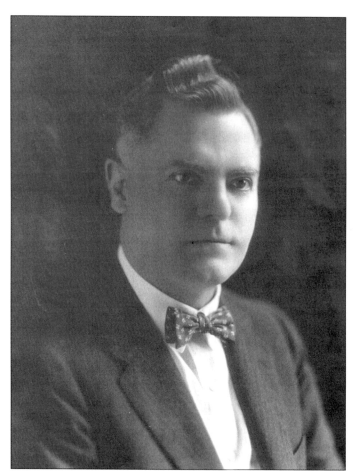

BOB QUINN.

If Diogenes had encountered Bob Quinn, he'd have thrown away his lantern and ended successfully his search for an honest man.
–John Kieran, "Sports of the Times," *The New York Times*, April 5, 1954.

In the spring of 1917, shortly after Branch Rickey left the Browns to become president of the Cardinals, Phil Ball hired Bob Quinn as Rickey's replacement as the Browns' business manager. Quinn had spent 17 years in Columbus in various roles, from catcher to manager to business manager. He was also one of the founders of the American Association. In the next six years, he surrounded George Sisler with a supporting cast that came within a game of the 1922 American League pennant. For six seasons, Quinn balanced the needs of a demanding owner with those of his ballclub. He pulled off the Urban Shocker deal and put together one of baseball's most unusual trades ever: he sent 11 men to Columbus for pitcher Dave Danforth. It just didn't work out the way he'd hoped.

As the 1922 season came to a close, two things happened. First, the generosity of Phil Ball (in the form of a bonus of 10 percent of the profits) put money into Quinn's pocket. Second, the impatience and disappointment of coming so close to the pennant increased Ball's meddling. So Bob Quinn put together a group of investors who bought the Boston Red Sox from Harry Frazee, resigned his position with the Browns, and took over as president of the Red Sox. Quinn spent the next 30 years in baseball, but never came as close to the pennant as he had in 1922 with the St. Louis Browns.

Soon after the purchase of the Boston team, principal investor Palmer Winslow died. Quinn could have folded his hand at that time. Instead he poured (and lost) much of his life's savings into the Red Sox. The Depression only made matters worse, and he finally sold the franchise to Tom Yawkey in 1933. Quinn then served as the general manager of Brooklyn and the president of the Boston Braves. None of these three franchises had a chance—the resources—to become a winner. In 1946, he became the Director of the Baseball Hall of Fame. In the meantime, his son Bob, Jr. took over the Braves and ran the club until 1958. Bob, Sr. did not live to see the 1957–1958 Milwaukee Braves' pennant winners; he died in 1954. (Courtesy of Margo Quinn Hemond.)

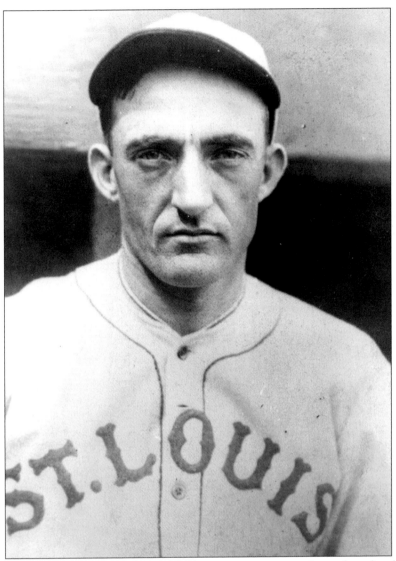

FRANK "DIXIE" DAVIS. He pitched arguably the most important and most heartbreaking game in St. Louis baseball history. On September 18, 1922, the Browns faced the New York Yankees in the final game of the "Little World Series," the showdown between the two teams vying for the AL pennant. With New York leading the Browns by one-half game, Davis took the mound. He held the Yankees scoreless for seven innings and took a 2-0 lead into the eighth, when the Yankees scored an unearned run. When they led off the ninth with an infield hit off Davis' glove, followed by a passed ball, Lee Fohl took Davis out. After enough moves and countermoves, breaks and heartbreaks, to fill a number of games, the Yankees rallied for a 3-2 win.

Davis didn't win his first game until his fourth trip to the bigs with four different teams: the 1912 Reds, the 1915 White Sox, and the 1918 Phillies—26 games and a 0-3 record, when he joined the Browns in 1920. He broke through with an 18-12 season. The following year, he pitched in one of those remarkable games that make baseball so compelling. He tossed a 19-inning complete game, an 8-6 win over Washington. Davis pitched a no-hitter for the last nine innings. In the 16th, he hit an apparent inside-the-park home run, but was called out for failing to touch one of the bases. (Courtesy of Brace Photo.)

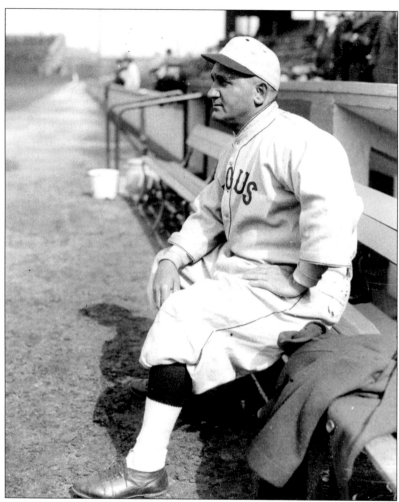

LEE FOHL. History has virtually forgotten this unassuming and quiet yet capable manager, who led the Browns to the brink of the pennant in 1922. Fohl was a cup-of-coffee catcher in the bigs (only five games, 1902–1903), who went on to manage more than 1,500 games in the majors. His deliberate personality was mistaken for indecision, and the press and fans undervalued him. This was certainly the case in the 'teens in Cleveland. Many people felt that Tris Speaker was really running the team, with Fohl a mere figurehead. The reality was that the men had a close working relationship, and Fohl did not seek publicity. During the 1919 season, Fohl departed the team by mutual agreement with the Indians' owner, after a tough loss (Babe Ruth hit a grand slam home run off the relief pitcher Fohl had just brought in, Fritz Coumbe). Tris Speaker then took over the team, and the squad that Fohl had largely assembled won the World Series in 1920.

After coaching for the Browns under Jimmy Burke, Fohl took the helm of the team in 1921. While the Browns were known as a good hitting team with little pitching (beyond ace Urban Shocker), Fohl coaxed a fine season out of many arms in 1922. That Browns' team led major league baseball in earned run average. Fohl was fired by owner Phil Ball the following year, when he refused to back his controversial pitcher Dave Danforth. In 1924, Fohl's former boss Bob Quinn hired him to manage the Boston Red Sox. Quinn had put together the investment group that bought the team from Harry Frazee. Without a lot of talent of the team, they finished at or near the bottom of the league in Fohl's three years at the helm. (Courtesy of the Chicago Historical Society.)

BILLY BAYNE. A lefty pitcher for the Browns from 1919 to 1924, he had a wicked curveball. He was unable to repeat his 1921 success, when he went 11-5, in the pennant campaign of 1922, when his record was only 4-5. On May 5, 1922, Bayne took a no-hitter against Detroit into the eigth inning. Player-manager Ty Cobb sent up five pinch-hitters in a row, and one of them got the Tigers' first hit. Another one of the men, Bob Fothergill, pinch hit for Cobb himself. It was a rare time in his storied career that a pinch-hitter batted for Cobb. In his biography of Cobb, John McCallum notes that Cobb had a career mark of 0 for 9 against Bayne. Exercising a "whammy" on Ty Cobb, according to Bayne, was one of his biggest baseball thrills. (Courtesy of the National Baseball Hall of Fame Library, Cooperstown, New York.)

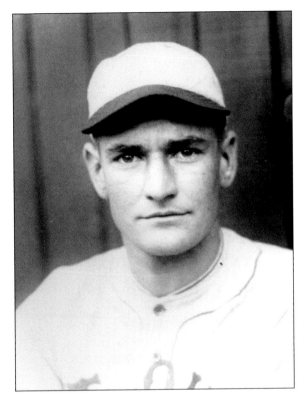

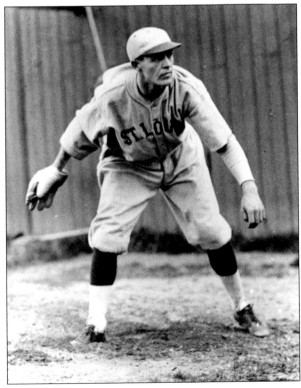

HUB PRUETT. He came up with the powerful 1922 Browns as a 21-year-old relief pitcher. He had a screwball, or fadeaway, that made Babe Ruth look foolish. More than half of the times he faced the slugger that year, Pruett struck him out. One of his few starts that year was a 5-1 win over the Yankees in Game Two of the "Little World Series." The screwball gave Pruett a chronic sore arm during his seven-year career. He later practiced medicine in St. Louis for more than 40 years. In 1948, shortly before Babe Ruth died, he and Pruett met at a banquet at the Chase Hotel in St. Louis. Pruett thanked the Babe: "If it hadn't been for you, no one would have heard of me." Ruth smiled and replied, "If there had been many pitchers like you, no one would have heard of me." (Courtesy of the Burton Historical Collection, Detroit Public Library.)

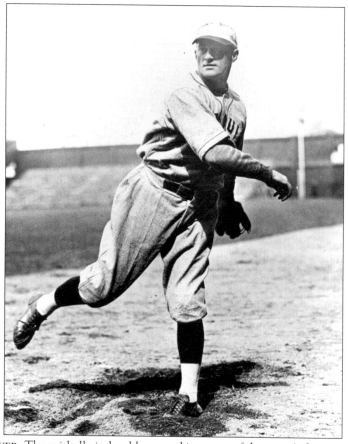

URBAN SHOCKER. The spitball pitcher blossomed into one of the game's dominant hurlers with the Browns from 1918 to 1924. In the first five years of the Lively Ball Era, 1920 to 1924, no pitcher won more games than Shocker did, 107. What is more remarkable is that he amassed these numbers, including four straight 20-win seasons, *despite missing virtually a month each season* from 1920 to 1923 due to injury or suspension. In 1920, for example, he missed the entire month of September due to a leg injury. In the heart of the 1922 pennant race, he went down with a ligament injury from June 11 until early July. Yet he still hurled 348 innings that season. In 1923, he was suspended for most of September in his remarkable battle for free agency. He insisted, against team rules, on taking his wife on the final road trip of the year. After his suspension, he took his case all the way to Commissioner Landis. It was a matter, *The Sporting News* wrote, that "would open the door for a legal fight that might shake baseball to its foundation." He ultimately reached a monetary settlement, with league president Ban Johnson's personal intervention.

Shocker was a colorful and volatile personality, supremely confident on the mound. He had memorable showdowns with Babe Ruth; there was no clear winner. He often got Ruth to strike out on his change of pace pitch, yet the Babe hit eight home runs off him from 1919 to 1924. In one memorable 1920 face-off, Shocker waved in his outfielders and then struck out the enraged Ruth. Shocker was known as a "Yankee jinx" for regularly beating the team that traded him away. Shocker insisted on pitching two games against New York in every four-game series. Ironically, in 1922, the odds caught up with him, and the Yankees beat him in a number of close games. This was the only year in which his winning percentage lagged behind that of his team, the very year the Browns fell just one game short of the pennant. (Courtesy of the Burton Historical Collection, Detroit Public Library.)

*I believe Shocker to have had more variety of stuff
than any other pitcher I have ever seen.*
 –John B. Sheridan, *The Sporting News*, August 11, 1927

LOADING UP. Shocker is seen here preparing a "wet offering," or at least suggesting to the batter that he was doing so. Shocker rarely threw his spitball, instead using it as a possible weapon and depended on his slow ball and, until late in his career, his fastball. The man who led the league in strikeouts in 1922 was winning by guile and brains in his later years, striking out only 35 batters in 200 innings in 1927. By the time he returned to New York in 1925, he had mellowed—in part because of his age and in part because of his secret struggle with the deadly heart disease that would take his life in 1928. Despite growing increasingly weaker and being unable to sleep lying down the last few years of his life (symptomatic of his mitral valve failure), he not only kept pitching but also won 37 games for the 1926 and 1927 Yankees. (Courtesy of the SABR–Ottoson Photo Archive.)

WILLIAM "BABY DOLL" JACOBSON. "Williams, Jacobson, and Tobin." Back in 1977, when the last member of the great Browns' outfield—Jacobson—died, sportswriter Bob Broeg wrote about the names that sounded like a law firm, or an accounting company. It was neither, though the group did rule in baseball, especially at the plate. From 1919 to 1925, the numbers were impressive:

Games/BA	1919	1920	1921	1922	1923	1924	1925
Bill Jacobson	120/.323	154/.355	151/.352	145/.317	147/.309	152/.318	142/.341
John Tobin	127/.327	147/.341	150/.352	146/.331	151/.317	136/.299	77/.301
Ken Williams	65/.300	141/.307	146/.347	153/.332	147/.357	114/.324	102/.331

So consistent, and so consistently too, these men, along with George Sisler, were the big reason why the Browns' offense was so potent. The team led the AL in hitting in 1920 (.308) and 1922 (.313). Jacobson hit for average and also was a remarkable fielder for a man his size. A career .311 hitter, he had a batting average of more than .350 in both 1920 and 1921. At 6'3", 215 pounds, he was one of the biggest men in the game. Yet he had tremendous instincts and reaction to the crack of the bat. At one time, he held more than a dozen fielding records.

Jacobson garnered the nickname in Mobile in 1912. When he hit a tremendous home run, the band broke out with one of the popular tunes of the day, "Oh You Beautiful Baby Doll." The next day, the *Mobile Register* ran his picture with the song name underneath. And the name stuck. Yet his road to stardom was not easy. He failed to stick in the bigs on five different occasions. He was originally the property of the New York Giants, who had three different looks at him. He also belonged to the Tigers, before the Browns got him in 1915. He finally broke through in 1919, and he credited manager Jimmy Burke with turning him around. In the past, Jacobson had been putting too much pressure on himself. Burke was an easy-going, cheerleading type, and he simply got his outfielder to relax. Baby Doll's game came together at the same time that it did for his two partners. (Courtesy of the National Baseball Hall of Fame Library, Cooperstown, New York.)

JACK TOBIN. One of the smallest (5'8", 142 lbs) and fastest men in baseball, he was a regular outfielder for the Browns from 1918 to 1925 and part of the great outfield of Williams, Jacobson, and Tobin. He was a St. Louis boy who developed "from the ground up" in the Federal League and then went on to stardom in the bigs, in his hometown. In 1913, fresh from the Trolley League, Tobin got his first pro opportunity from former Browns' manager "Rowdy Jack" O'Connor. O'Connor himself had starred on the sandlots of St. Louis and was managing the Terriers of the Federal League. In 1913, it was an independent minor league and had not started going after established stars. Tobin played there all three seasons of the league's existence, 1913 to 1915. A career .309 hitter, he had more than 200 hits four straight years, from 1920 to 1923. He hit .341, .352, .331, and .317 in those four seasons. He was considered the best drag bunter in the game and was an expert "place hitter." "Jawn," as he was affectionately called, returned to St. Louis baseball as coach of the Browns from 1949 to 1951. He was chosen as the utility outfielder on the all-time St. Louis team in 1958. (Courtesy of Michael Mumby.)

GENE ROBERTSON. St. Louis-born and St. Louis University-educated, he played third base for the Browns in the early 1920s. He had solid years in 1924 and 1925 (.319 and .271 batting averages, respectively). He was let go to the minors in 1927 and then signed with the 1928 Yankees, with whom he played in the World Series. He was one of a number of St. Louis Browns who ended up on one or more of the Yankee pennant winners of 1926, 1927, and/or 1928: Urban Shocker (1926-1927-1928), Joe Giard (1927), Pat Collins (1926-1927-1928), Gene Robertson (1928), Cedric Durst (1927-1928), and Hank Severeid (1926).(Courtesy of *The Sporting News*.)

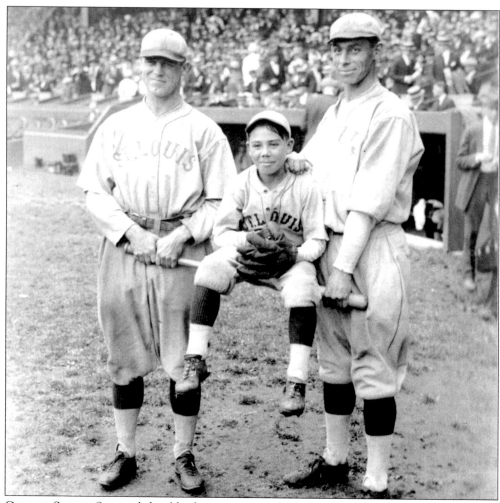

GEORGE SISLER. Sprained shoulder ligaments in early September 1922 prevented Sisler (left) from breaking his own record of 257 hits, set just two years earlier. Despite missing 12 games and playing with limited mobility in a number of others, he still got 246 hits and finished with a .420 batting average. That injury really hurt the Browns in the "Little World Series" against the Yankees—the Browns lost two of three in that crucial September showdown, when Sisler managed just two hits in eleven at-bats. Yet it was nothing compared to the vision problems Sisler soon developed from a sinus infection—missing the entire 1923 season and never again approaching the zone he occupied before 1923. He became the Browns' player-manager only reluctantly, just as another local hero had assumed those duties more than a decade earlier (Bobby Wallace). Sisler still remembered Fielder Jones walking away from the pressures of the job. Business manager Bob Quinn had offered Sisler the manager's job back in 1921, before Lee Fohl took over. Sisler declined it back then, to keep his focus on hitting. This time, there was the possibility that he'd never play again, and managing would keep him in the game. So Sisler became the Browns' skipper for three seasons, with the 1925 third-place finish as the high point. He was later sold to Washington and ended his playing career with the Boston Braves. Years later, when Branch Rickey went to Brooklyn and then Pittsburgh, he hired Sisler as his scout and hitting instructor. He was elected to the Baseball Hall of Fame in 1939. He is seen here in late August 1922, with Browns' outfielder Kenny Williams and team batboy Joe Ryan. (Courtesy of Culver Pictures.)

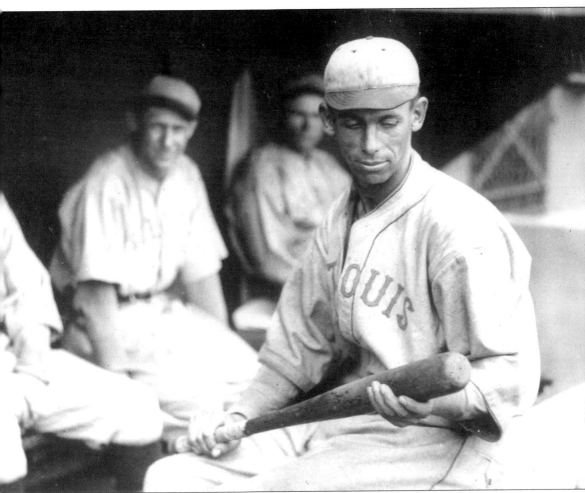

KEN WILLIAMS. The most well known member of the Browns' great outfield of the early 1920s, he hit for power and for average. A career .319 hitter, higher than his partners Jacobson and Tobin, in 1922 Williams led the AL in home runs and runs batted in (39, 155). From 1921 to 1923, his batting average was .347, .332 and .357. Three times his slugging percentage exceeded .600. He also was the first player to hit 30 home runs and steal 30 bases in the same season. He did it in 1922. That season was special for Williams in other ways as well: he hit three home runs in a game (April 22), he hit home runs in six straight games (July 28–August 2), and he hit two home runs in one inning (August 7). In 1925, Williams was having his finest season when he was hit in the head by a pitch in August and severely hurt. Though he missed a number of games, he still led the league in slugging average that year with a .613. (Courtesy of the Private Collection of Dennis Goldstein.)

DAVE DANFORTH Controversy dogged him when he joined the Browns in 1922. His suspension that year may have cost the team the pennant, and his suspension the next year may have cost the team's manager his job. After Danforth won 25 games for a last-place Columbus team in 1921, the Browns acquired him in exchange for 11 men, which may have been some kind of record. He was to be the missing link in the Browns' drive for the '22 pennant.

It was not his first trip to the bigs. In 1911, Danforth was a late-season reliever for the Philadelphia Athletics, and in 1917, he appeared in 41 games in relief for the Chicago White Sox. In both seasons, he gained a World Series winner's share. While with the White Sox, he had been accused of doctoring the ball, of throwing everything from a paraffin ball to an emery ball to cutting the seams. He also had discovered the shine ball while in Louisville and taught it to a White Sox teammate who soon turned his career around. His name was Eddie Cicotte, and he became one the game's great hurlers until he was banned for life for his involvement in the Chicago Black Sox scandal.

His [Danforth's] work on the pitching mound has been more carefully scrutinized and more universally criticized than that of any pitcher on record, not excepting the ill-omened [Carl] Mays.
–F.C. Lane, Baseball Magazine, July 1924

In 1922 Danforth brought his reputation for throwing trick pitches back with him to the majors. Umpires and opponents were constantly checking the balls he threw, yet as in the past, they found nothing. Then on July 27, in a game against the Yankees, the umpire tossed Danforth for throwing a ball with loaded seams (of mud or dirt), and an automatic 10-game suspension followed. Despite the fact that the Browns were in a fierce pennant race with New York, they sent him to Tulsa, where he spent the rest of the year. Manager Lee Fohl and business manager Bob Quinn simply did not want him on their team. So the team that lost the pennant by only one game that year lost a talented pitcher for more than two months. The man who won 25 games in 1921 won but five for the St. Louis Browns in 1922.

In 1923, owner Phil Ball insisted that Danforth rejoin the team. He was once again tossed from a game and suspended, this time for throwing a ball with rough spots. Bob Quinn had already resigned, and Ball soon fired manager Lee Fohl for not backing up his pitcher.

No one ever caught Dave Danforth throwing any illegal pitch. He was said to have an abrasive fingernail on his left hand, as well as an extremely coarse hand. He kept his throwing hand out of public view, saying he suffered from embarrassing eczema. What he did have was unusually large and powerful hands, probably strong enough to loosen the cover of the ball. After his baseball career, he was a practicing dentist in Baltimore for many years. (Courtesy of the Mercantile Library/UMSL.)

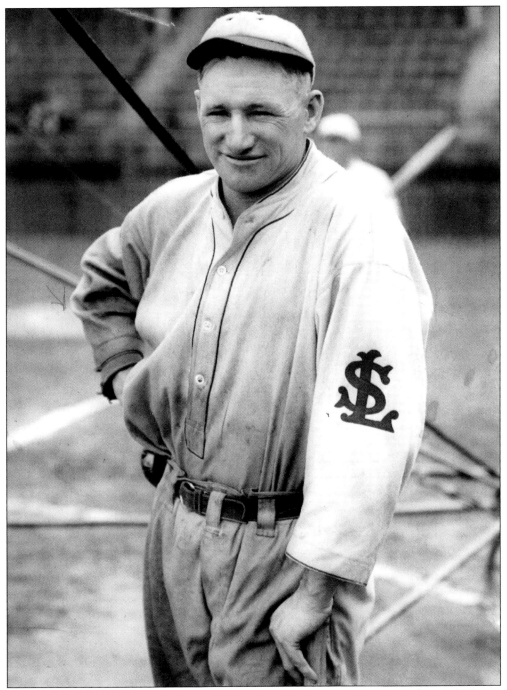

JIMMY AUSTIN. He spent more than two decades with the Browns as a player and a coach. Jimmy was one of Branch Rickey's first "Sunday managers." (Rickey did not come to the ballpark on Sundays because of a promise he'd made to his mother.) Popular with his teammates, Austin was the Browns' "utility manager." Three times he stepped in to manage the team on an interim basis: 1913 (8 games, after George Stovall was fired), 1918 (16 games, after Fielder Jones resigned), and 1923 (51 games, after Lee Fohl was fired). (Courtesy of the Mercantile Library/UMSL.)

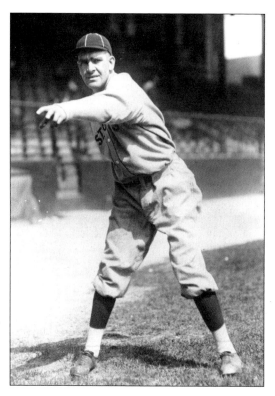

ELAM VANGILDER. He pitched for the Browns from 1919 to 1927. Vangilder won 19 games for the 1922 Browns and also helped his own cause by hitting .344 with two home runs and 11 runs batted in that year. He became a relief pitcher by 1925, appearing in 52 games and starting only 16 times. He often had control problems—he led the league in walks in 1923. Yet in 1922, for one season, he pulled it all together, with only 48 walks in 245 innings. A big man (6'1", 192 lbs), Vangilder had a career mark of 99 wins and 102 losses, all but 11 of each with the Browns. He was traded to Detroit with Harry Rice in 1927. (Courtesy of the Cleveland Public Library, Photograph Collection.)

MAX FLACK. He was one of a small group of players who started in the Federal League and went on to a long career in the majors. (Jack Tobin was another.) Flack was also one of an even smaller group of players who were traded between games of a double-header to the team he was playing against that day. The Cubs sent him to the Cardinals for Cliff Heathcote in May 1922. Flack went home for lunch as a Cub (he lived in St. Louis, near Sportsman's Park) and came back as a Cardinal. He and Heathcote switched uniforms, and each man won a game that day, as the Cubs swept the Cardinals. Flack was one of the leading right fielders of his time and also an excellent leadoff hitter. After filling that role for the 1923 Cardinals, he was a utility player the next two years and was gone by 1926. Branch Rickey was a tough and clever negotiator, and Flack knew that only too well. During 1923 salary talks with the player, Rickey suggested that Flack go to the West Coast, where he could play every day in the Pacific Coast League. Flack didn't want to leave St. Louis, so he told Rickey he'd take a pay cut to stay with the Cards. "That will be fine," replied Rickey, who cut $1,500 from his outfielder's salary. (Courtesy of the Mercantile Library/UMSL.)

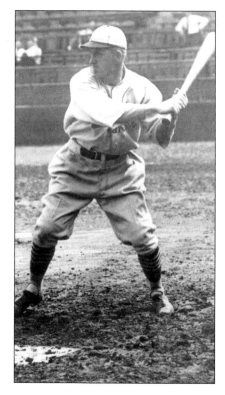

JOE SCHULTZ. He was on four teams in his first four years in the bigs, before settling in with the Cardinals from 1919 to 1924. He hit lefties extremely well, but he had trouble with right-handed pitchers and therefore did not play regularly. Only once in his 11-year career did he play in more than 100 games, in 1922. He hit .314 that season, after a .309 mark the year before. A cousin of Deadball Era star Hans Lobert, "Germany" gained his name from his background. His son was a Cardinals' mascot in the early 1920s, at the age of five. Years later, when Schultz was scouting for Pittsburgh, he signed his son to a contract. Joe, Jr. was a utility player for the Cards in the 1940s and later managed in the majors, including the Seattle Pilots in 1969. (Courtesy of Michael Mumby.)

RAY BLADES. He was one of the first players to come up through the Cardinals' farm system in 1922. Blades was a utility player with a lifetime .301 batting average in a ten-year career with the team. The Cardinals spotted him at one of the first open tryouts they sponsored. He joined the team late in the 1922 season, after hitting .330 with a league-leading 20 triples for Houston that year. After hitting .342 in 122 games for the 1925 Cards, Blades tore up his knee, an injury from which he never fully recovered. In 1939, he took over as manager from Frank Frisch and led the Cardinals to a second-place finish with 92 wins. A poor start the next season cost him his job. One of Branch Rickey's favorites, Blades was a coach for the Dodgers in 1947 and 1948 under manager Burt Shotton, his Cardinal teammate of his rookie season. (Courtesy of Michael Mumby.)

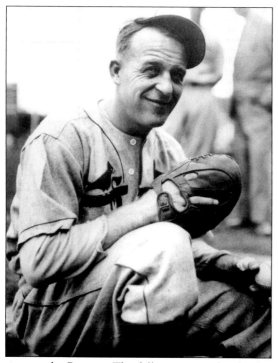

"SUNNY JIM" BOTTOMLEY. He and Ray Blades were the first Cardinals who came through the team's farm system in 1922. Bottomley hit only .227 for Houston in 1921, but he was bothered by injuries. The following year he was healthy, and after he hit .348 for Syracuse, the Cardinals brought him up late in the season. He replaced Jack Fournier at first base in 1923. Fournier went to Brooklyn, where his lively bat was still good for a .351 batting average. But Bottomley hit .371 that year, his first full season. In September 1924, he set a record by knocking in 12 runs in a single game. In 1925, he hit .367 and led the league in hits and doubles. A favorite of the Knothole Gang, Bottomley had thousands of kids cheering when he won the league's Most Valuable Player award (then called the National League award) in 1928. After three seasons in Cincinnati, he returned to St. Louis in 1936, this time to the Browns. The following year, his final as a player, he also managed and coached the Browns. He had a career slugging percentage of exactly .500, the same as Tris Speaker. Bottomley was elected to the Baseball Hall of Fame in 1974. (Courtesy of Michael Mumby.)

CHICK HAFEY. He started his career as a pitcher, and Rickey converted him to an outfielder when the Cardinals signed him. Hafey's .360 batting average with 20 triples for Houston in 1924, on his way up the Cardinals farm system, proved that the conversion was a good idea. In 1925 he hit .302 for the Cardinals. Hafey developed sinus trouble in 1926, had surgery in the off-season, and then started wearing glasses. He went on to his six best seasons from 1927 to 1932, hitting .329, .337, .338, .336, .349, and .344. The .349 mark won the batting title in 1931, in an incredibly close race: Hafey hit .3489, New York's Bill Terry hit .3486, and Hafey's teammate Jim Bottomley hit .3482. He finished with a career batting average of .317. As with the Browns' George Sisler, one can only wonder how good these Hall-of-Famers would have been had they not had eye problems. Hafey was elected to the Baseball Hall of Fame in 1971. (Courtesy of the Mercantile Library/UMSL.)

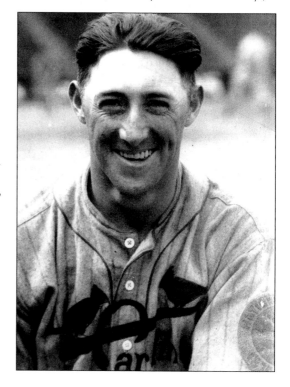

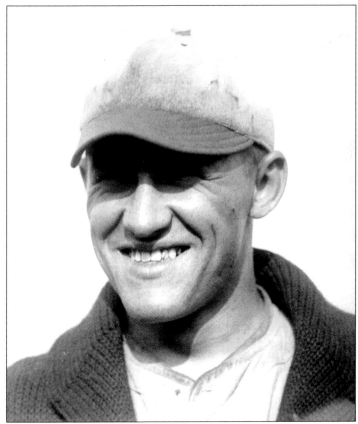

CLARENCE "HEINIE" MUELLER. Charlie Barrett discovered him on the sandlots of St. Louis, and he soon became a favorite of Branch Rickey. Mueller, an amusing character with an infectious smile and laughter, joined the Cardinals in 1920 and spent more than six years as the team's utility outfielder. He hit above .300 in four of those seasons, including two years above .340. But the Cards had enormous depth at those positions, with the farm system producing so well, and Mueller never broke into the starting line-up on a regular basis.

Another reason why he stayed on the bench may have been his antics on the basepaths. Also known as "Rockhead," he was once sent down to the minors after a base-running blunder, running from first to third base with his head down, on a ball the catcher easily caught. Sportswriter James Gould was moved to write, "That play of yours was the first time I ever saw a big leaguer go from first base to Houston on a pop-up in front of the plate." On another occasion, he was trying to make the case with Branch Rickey that he should be starting in the outfield instead of Jack Smith:

"I'm faster than Smith." (Smith averaged more than 20 stolen bases a year over a ten year period.)

"Judas Priest," exclaimed Rickey, using one of his expressions.

"How fast could *he* run?" asked Heinie, so nicknamed because of his German heritage.

He did not participate in the Cardinals' first World Series in 1926. He was traded that June to the New York Giants for outfielder Billy Southworth, a move that solidified the team for the stretch run. Almost a decade later, after an absence of six years from the bigs, he reunited with Rogers Hornsby, now the Browns' manager, and appeared in 16 games. In his later years, Mueller did share in the excitement of Cardinal pennants. He was married to the daughter of Cardinals' scout Charlie Barrett and became a Cardinals' scout himself in the late 1930s and early 1940s. Mueller also ran the team's tryout camps during those years. (Courtesy of Michael Mumby.)

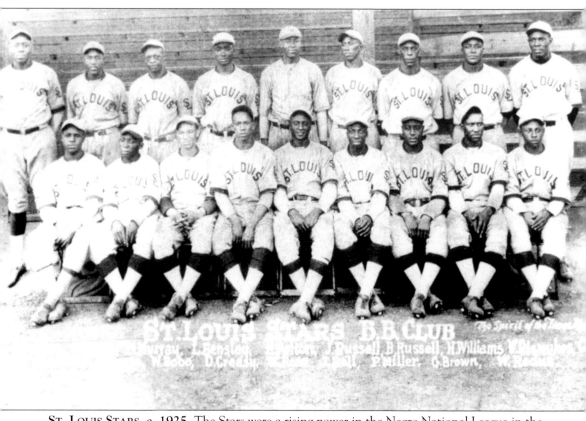

ST. LOUIS STARS, c. 1925. The Stars were a rising power in the Negro National League in the mid-1920s. George "Mule" Suttles (back row, far left) was a free-swinging power hitter who would "kick" the ball out of the park; he hit massive home runs and also hit for average. He was the first baseman of the Stars' three championship teams—1928, 1930, and 1931. Willie Wells (back row, second from left) played shortstop for the three championship teams. Mitchell Murray (back row, third from left) was the Stars' starting catcher, 1923 to 1928. Logan "Slap" Hensley (back row, fourth from left) came out of St. Louis' Tandy League, went straight to the Stars in 1922, and was the ace of the 1930 champions. He played with them through 1931. William "Dizzy" Dismukes (back row, far right), who started out pitching in the sandlots of East St. Louis, Illinois, was a submarine pitcher with many breaking-ball pitches. He was on the great 1928 team and took over the Chicago American Giants after Rube Foster's death in 1930. Roosevelt "Duro" Davis (front row, far left), a pitcher for the Stars from 1924 to 1931, had a huge repertoire of pitches, including the spitter. Willie Bobo (front row, third from left) shared first base duties with Suttles. Dewey Creacy (front row, fourth from left) was the starting third baseman of the 1923–1931 Stars. He took advantage of the team's short left field fence. (A trolley-car barn jutted onto the field, creating the unusual dimensions). James "Cool Papa" Bell (front row, fourth from right), often simply called "Cool," played on three of the greatest black teams in history: the Stars, the Pittsburgh Crawfords, and the Homestead Grays. (Courtesy of the Jay Sanford Collection.)

JAMES "COOL PAPA" BELL. Possibly the fastest man in baseball history, he earned his nickname for calmly striking out Oscar Charleston in a pressure situation at the age of 19. That year, 1922, Bell signed his first pro contract with the St. Louis Stars. He stayed with that team for a decade, including the championship teams of 1928, 1930, and 1931. He was a pitcher in his first two seasons, before becoming an everyday outfielder in 1924. In 1951, at the age of 48, he turned down the offer of St. Louis Browns' owner Bill Veeck to join the team, though he did scout for the team. He was elected to the Baseball Hall of Fame in 1974. (Courtesy of the National Baseball Hall of Fame Library, Cooperstown, New York.)

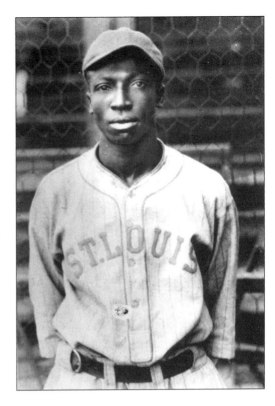

"CANDY JIM" TAYLOR. He was the player-manager of the St. Louis Stars for most of the 1920s, including the championship team of 1928. A good-hitting third baseman, Taylor starred on the great Indianapolis ABC's of the mid-'teens. He is remembered most for his long managerial career, which included the champion Homestead Grays of 1943 and 1944. In 1936, he managed a black all-star team that captured the Denver Post tournament. His years at the helm of the St. Louis Stars corresponded with those of the team's best player, James "Cool Papa" Bell. (Courtesy of the Jay Sanford Collection.)

Hornsby and Ruth. (*opposite page*): Hornsby (left) put together six seasons that were almost incomparable. From 1920 to 1925, the Rajah led the league in batting average, slugging average, and on-base percentage each year. He hit above .400 three times; none of his seasons was below .370. Only Ty Cobb had strung together numbers like these, about a decade earlier. Hornsby's bat also generated power—he led the league in home runs twice, including a NL record 42 in 1922. In both 1922 and 1925, Hornsby won baseball's Triple Crown—leading the league in home runs, runs batted in, and batting average. The National League introduced its MVP award in 1924 (the Chalmers Award had stopped in 1914). Despite Hornsby's stellar season, the prize instead went to pitcher Dazzy Vance that year. He had a 28-6 record, with 262 strikeouts, and a 2.16 earned run average, all tops in the league. "The Rajah" won the MVP award the following year and again in 1929.

Then there was Hornsby's personality. He was a blunt and cold man, not just scrappy, but contentious. While these traits emerged more after 1925, when Hornsby was leading men and not simply focusing on hitting a baseball, the seeds were there earlier. In 1923 he tussled in the locker room with his manager Branch Rickey. Yet there doesn't appear to be a pattern of sabotage to undermine Rickey's position. When Sam Breadon removed Rickey as manager early in the 1925 season, that decision resulted from the team's poor start, dwindling advance ticket sales, and the impatience of the team's owner. Breadon gave the job (now player-manager) to Hornsby. Interestingly, he had his poorest hitting season in years in 1926, his first full year at the helm. Whether that was related to the weight of his new responsibilities or the illness of his mother (who died later that year) is not known. But the .317 batting average was far below his 1920–1925 numbers.

Nevertheless, Hornsby led the Cards to their first pennant and world championship in 1926. Ironically, the skipper who would gain such a reputation for obstinacy and inflexibility had no problem adding veteran pitcher Grover Cleveland Alexander to his staff mid-season. Alex had a reputation for drinking (something Hornsby never did) and for "violating training rules." His Chicago Cubs' manager had put Alexander on waivers for his behavior, and that manager went on to greatness as a Yankee manager, Joe McCarthy.

In one of the most famous and at the time controversial moves in St. Louis baseball history, Sam Breadon traded Hornsby away shortly after he had led his team to victory in the World Series. Luckily for Breadon and the Cardinals, one of the men they got in return was another future Hall of Fame second baseman, Frank Frisch, who had strong leadership skills.

Hornsby then embarked on another string of incredible seasons. From 1927 to 1929, he hit between .361 and .380 and led the league in both slugging percentage and on-base percentage twice. Equally remarkable is the fact that each season he was with a different team (Giants, Braves, and Cubs). He just didn't "wear well" with his owners or teammates. It is apt that, years later, he entitled his autobiography My *War with Baseball*.

In the summer of 1933, after he had started the season with the Cardinals, Hornsby signed with the Browns as player-manager. His playing career was nearing its end (only 67 games with the Browns, from 1933 to 1937), and his team was mired in the second division. He also managed the Browns in 1952. He was fired mid-season in both of these stints. Still, he is most remembered as a batting perfectionist, a magnificent hitter who lived to hit. And when he retired, he loved to talk about hitting. At the same time that Hornsby was posting these numbers, the Cardinals were becoming more and more competitive. During the 1920s, comparisons between Hornsby, Ruth, and Sisler kept the Hot Stove League going each winter. Here are Hornsby (on the left) and Babe Ruth in a lighter moment. The only time they went head-to-head (other than exhibition games) was in the 1926 World Series. Ruth hit .300 with four home runs, and Hornsby hit .250. The Rajah was elected to the Baseball Hall of Fame in 1942. (Courtesy of Culver Pictures.)

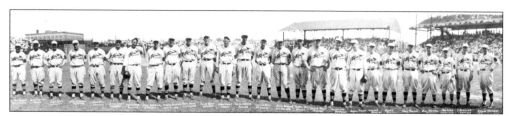

1925 ST. LOUIS CARDINALS. Here are many of the players who will be on the championship team the following year. The key additions still to come in 1926 (not yet on the team here in 1925) are pitcher Grover Cleveland Alexander and outfielder Billy Southworth. Pictured here, from left to right, are Ray Blades, Burt Shotton, Jack Smith, Bob O'Farrell, Ernie Vick, Jimmy Cooney, Eddie Dyer, "Specs" Toporcer, Taylor Douthit, Chick Hafey, Flint Rhem, Jesse Haines, Leo Dickerman, Lester Bell, Ralph Shinners, "Pea Ridge" Day, Duster Mails, Sunny Jim Bottomley, Johnny Stuart, Walter Schmidt, Allan Sothoron, John Morgan, Bill Sherdel, Max Flack, F. Schiller, and Rogers Hornsby. (Courtesy of the St. Louis Cardinals Hall of Fame Museum.)

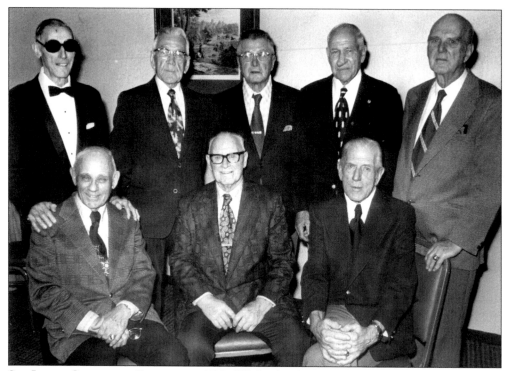

ST. LOUIS CARDINALS REUNION, 1976. While this January 1976 dinner brought together members of the 1926 World Series championship team, most of these players were on the Cardinals before 1926. Only Syl Johnson and Joe Mathes were not on the 1925 team. Bob O'Farrell came over early in 1925, in exchange for Mike Gonzalez. Ernie Vick was a utility player, and Joe Mathes was a former big leaguer and long-time scout in the St. Louis area. He played for the Terriers of the Federal League back in 1914. He was the recipient of the Dr. Robert F. Hyland award for meritorious service to baseball. Pictured, from left to right, are (front row) Ray Blades, Bob O'Farrell, and Sylvester Johnson; (back row) George Toporcer, Bill Hallahan, Ernie Vick, Lester Bell, and Joe Mathes. (Courtesy of the Mercantile Library/UMSL.)

SIX
They Also Served

ROY STOCKTON. A sportswriter with the *Post-Dispatch* for 41 years, he was also a well-known author and radio personality. Stockton started working for *The Republic* and then moved to the *Globe-Democrat*. His first assignment was to cover the Federal League's St. Louis Terriers' 1915 spring training in Cuba, where he also reported on the Jack Johnson-Jess Willard boxing championship. Stockton then settled in with the *Post-Dispatch* in 1917. Stockton covered the Browns until 1926, when he moved over to the Cardinals. He wrote a classic book, *The Gas House Gang and a Couple of Other Guys*, and also co-authored biographies with Rogers Hornsby and Frank Frisch. Stockton wrote numerous articles for *Saturday Evening Post* and *Look*, with his signature witty and clever style. He was often seen with his familiar pipe clenched in his teeth. He also had a radio sports talk show from the early 1930s to the late 1940s and was elected the president of the Baseball Writers' Association of America in 1932. Bob Broeg wrote in Stockton's obituary that his mentor "could thrust so cleanly that he didn't even draw blood." Stockton was awarded the J.G. Taylor Spink award shortly after his death. (Courtesy of *The Sporting News*.)

DR. ROBERT HYLAND. Dubbed the "Surgeon General of Baseball" by Commissioner Landis, he was the physician of both St. Louis major league teams for many years. While his guiding philosophy was to avoid surgery whenever possible, he is best remembered for the delicate and complex operations he had to perform on many ballplayers, from home and visiting teams alike. Hyland played minor league ball in 1908 for the Grand Rapid Wolverines of the Central League, managed by Bobby Lowe, a former major league star. Hyland then went to St. Louis University Medical School, where he got his medical degree in 1911. He soon became the surgeon for St. Louis' streetcar and bus companies. Hyland became the team doctor of the Browns, and when Branch Rickey moved to the Cardinals, Hyland took on that team too. He refused to take money for his services with the ball clubs and never did so. Dr. Hyland saved many baseball careers and perhaps some lives. The list of emergencies and operations he handled include Earle Combs' skull fracture in 1934, when he ran full-throttle into the concrete outfield wall at Sportsman's Park, and Mel Ott's serious beaning in 1931, from a Burleigh Grimes' pitch. Dr. Hyland also had many well-known ballplayers as his patients, including Babe Ruth and Ty Cobb. He practiced medicine up until his death in 1950. His son was the president of St. Louis radio station KMOX for many years. (Courtesy of *The Sporting News*.)

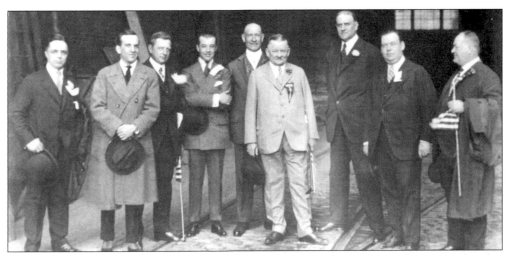

J.G. TAYLOR SPINK. He took over as the editor and publisher of *The Sporting News* when his uncle Alfred died in 1914 and built it up to be known as "the bible of baseball." Called "the unofficial conscience of baseball," Spink was not afraid to stake out unpopular positions and even take on Commissioner Landis. He instituted a number of awards, sometimes in competition with those of the Baseball Writers' Association of America (BBWAA). Shortly after Spinks' death in 1962, an award bearing his name was established, recognizing outstanding journalists. He was its first recipient. Spink is seen here, in the late 'teens, on the far left. The others include (left to right): Al Jolson, entertainer; John Heydler, National League president (1909, 1918–1934); August Busch, future chairman of Anheuser-Busch and future Cardinals' owner; Tom Hickey, American Association president; Garry Herrmann, Cincinnati Reds' owner and president of the National Commission (1903–1920); Gov. John Tener, NL president (1913–1918); unidentified, Cincinnati Mayor George Puchta (1916–1917). (Courtesy of *The Sporting News*.)

JOHN B. SHERIDAN. "J.B." was a longtime St. Louis sportswriter who had a regular column in *The Sporting News* for many years. "Back of the Home Plate," on the editorial page, was widely respected for its grasp of baseball history and issues. Sheridan started writing for the *Globe-Democrat*, and he later wrote for the *Republic* and the *Post-Dispatch*. Yet his biggest contribution to St. Louis baseball was a sandlot team that he organized, the Wabadas, which focused on youngsters under the age of 17. "Sherry," as he was also known, paid the boys and gave them responsibilities, including maintaining the ball fields. In 1914, they won the St. Louis Trolley League championship, and a year later the team disbanded—so many of its members entered organized ball. The list of Wabadas who became major leaguers includes catcher Muddy Ruel, Andy High, who played for the Cardinals' 1928, 1930 and 1931 pennant winners, and Charlie Hollocher, shortstop for the Chicago Cubs in the 1920s. (Courtesy of *The Sporting News*.)

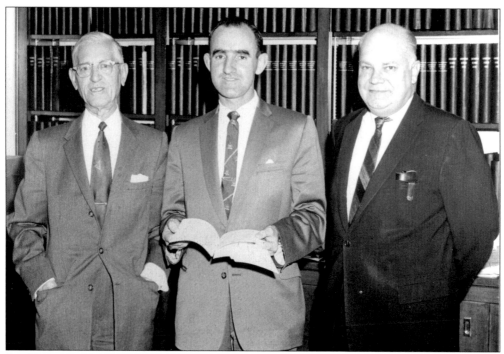

SID KEENER.

I was born to baseball…I leaped to joy [sic] in 1900 when
Cy Young invited me to become clubhouse boy.
–Sid Keener, in a letter to Bob Burnes, *Globe-Democrat*, July 27, 1963

Keener recalled one player who didn't want a clubhouse boy and snarled at the 12-year-old to get out. That man was future New York Giant skipper John McGraw. Keener solved the problem by making sure McGraw's shoes were always shined when he came back from the playing field. For more than six decades, Sid Keener was connected to baseball, starting in St. Louis and ending in Cooperstown.

Born in 1888, he became a copy boy for *The Star* in 1901. In 1907 he joined *The* [St. Louis] *Times* sports staff. In 1914, at the age of 25, he became sports editor of *The Times*. He moved back to *The Star* in 1929 and became sports editor of the merged *Star-Times* until 1951, when the paper folded. He was out of work only a year, when he became the Director of the Baseball Hall of Fame, succeeding Bob Quinn, former business manager of the Browns. Keener served in that capacity until 1963. He is seen here at his retirement party (on the left), with the Hall's historian Lee Allen (on the right).

One of Keener's favorite stories was the scoop he was given as a young reporter by Cardinal manager Roger Bresnahan one spring. Bresnahan told the reporter that star first baseman Ed Konetchy wasn't happy with his contract, which the two of them would thrash out at a restaurant that morning. When Keener stopped by, the men had a few bottles of beer on the table. The skipper told Keener to come back later since the men really hadn't gotten into the contract. Keener returned at lunchtime, when there were more empty bottles of beer lying around. "You're still too early," the reporter was told. Finally, Keener returned a few hours later, with the men surrounded by many beer bottles. "Everything's O.K.," said the smiling manager. "Ed said I'd have to pay him what he demanded if he drank me under the table. But we're both on deck and he has to take what I offered." (Courtesy of the National Baseball Hall of Fame Library, Cooperstown, New York.)

CHARLIE BARRETT. As a long-time St. Louis scout, he uncovered hundreds of players and signed dozens for the Browns, and later, the Cardinals. Born in St. Louis, he played sandlot and minor league ball, and he got to know Branch Rickey when both men played in the Texas League. Hired by Browns' owner Bob Hedges in 1909, he signed pitcher Earl Hamilton and catchers Bill Killefer and Hank Severeid. Among the Cardinals he found and signed were Ray Blades, Jim Bottomley, Charlie Grimm, Chick Hafey, Pepper Martin, Heinie Mueller, Flint Rhem, and Muddy Ruel. In a 2004 interview, Gene Karst vividly recalled Barrett's warmth and kindness, 74 years after the scout had befriended the Cardinals' first publicity man in 1930. Barrett inscribed this photo, "To my Friend, Frank Frisch." (Courtesy of the National Baseball Hall of Fame Library, Cooperstown, New York.)

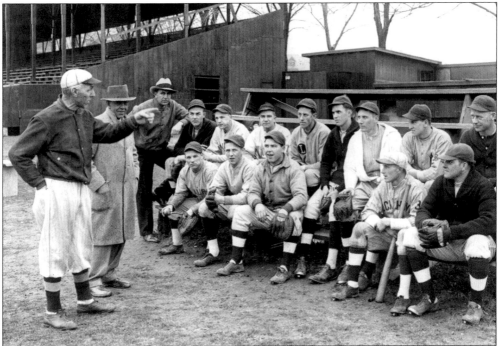

CARDINAL TRYOUT CAMP. Cardinal coach and scout Joe Sugden is seen here (pointing) with head scout Charlie Barrett (in the overcoat and top hat) at an "open" tryout camp, like the ones in which Ray Blades and Jim Bottomley were discovered. (From the St. Louis *Globe-Democrat* staff photographer, Hangge Collection, courtesy of the Missouri Historical Society.)

JAMES M. GOULD. A longtime St. Louis sportswriter and then sports editor of *The Star* (1919-1928), he then went to write for the *Post-Dispatch*. He was also a regular contributor to *Baseball Magazine* and was the president of the Baseball Writers' Association of America (BBWAA) from 1924 to 1926. A graduate of the U.S. Military Academy in West Point (1903), Gould served in the Philippines with General Pershing. Gould later joined Mexican rebel leader Pancho Villa as his mercenary Chief of Artillery. When General Pershing later told Gould that he would have shot Gould had he (the general) caught up with the rebels, Gould smiled and explained that the pay was simply too good to turn down the job offer. "Fifteen hundred a month—in gold." Pershing quickly replied, "Goddammit, I was making only $900." (Courtesy of the National Baseball Hall of Fame Library, Cooperstown, NY.)

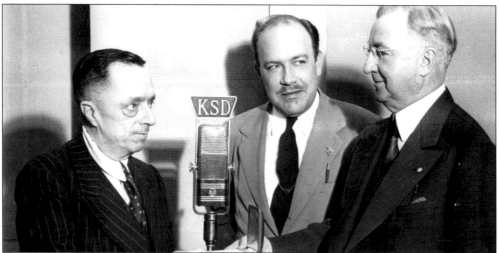

ED WRAY. He had a remarkable career covering St. Louis baseball for more than half a century. Wray joined the *Post-Dispatch* in 1900 and became sports editor a couple of years later. He moved over to the *Globe-Democrat* for a few years and then returned to the *Post-Dispatch* as sports editor in 1908 and held the position until 1946. His "Wray's Column" continued to appear until 1955. A charter member of the Baseball Writers' Association of America (BBWAA), Roy Stockton trained under him and became the sports editor when Wray retired. Wray once wrote that he thought he was a Browns' jinx since he had covered all three close pennant races the Browns lost: 1902, 1908, and 1922. Known as "Ed," his middle name, he copyrighted the Past Performance chart that became an integral part of the (horse) racing form. Here he is seen (on the right) accepting an award from C.G. Taylor Spink, with broadcaster Frank Eschen in the middle, looking on. (Courtesy of the Mercantile Library/UMSL.)